Wolf Kahn *Landscape Painter*

Martica Sawin

Taplinger Publishing Company
New York, New York

First printing
Published in the United States in 1981 by
Taplinger Publishing Co., Inc.
New York, New York

Library of Congress Catalog Card Number: 81-51081
ISBN 0-8008-8420-5
ISBN 0-8008-8421-3 (pbk.)

Introduction

Landscape, what can it mean as a subject for the artist in the 1980's? Since the earliest known landscape at Catal Hüyük some 8000 years ago, man has attempted to represent the space in which he exists, first as ideograms and stylized abbreviations, triangles for mountains, herringbone pattern for water, then as a simulacrum of visual experience, introducing that illusionism which offended Plato in the 5th century B.C. For the Greeks and Romans this surface-denying, three-dimensional, and atmospheric landscape existed principally as a backdrop for episode from myth and history, although it could reach grand proportions and dwarf the principal actors. It could also, on the windowless walls of Roman interiors, function as decor that visually expanded the space, like the wallpaper murals of more recent times. Devices from Roman and Hellenistic painting were frozen into signs for locale from Early Christian to Romanesque art when symbol replaced sensory experience. Art pointed the way toward scientific observation as oak leaf and grape vine replaced the tired acanthus leaf in the 13th century, and a new landscape painting began to emerge under the mantle of symbolism in which each particle was important as a reflection of the glory of creation, and every flower had its meaning.

For the Renaissance the painted landscape was space to be measured and traversed, and frequently it was an actual portrait of a place. To this the 17th century added light, dramatic for Ruisdael or Rubens, serenely luminous for Claude and the classical school. It was a vehicle for both the picturesque and the sublime in the formulas of the 18th century and a means of registering the perception of changing light from Constable through Monet. Until Monet there were commonly accessory figures or *staffage*, but they have no place in his screen of reflected light, any more than in the uneasy space of a Cézanne landscape. With Cézanne landscape assumes a new role as the battleground of a personal struggle to reconcile ambiguities. For the Expressionists it becomes the embodiment of personal disharmony and anxiety.

It is in this last role that landscape as a subject matter has persisted in 20th century art, since it can have little general significance in our time bent as it is on its destruction and exploitation, while cordoning off artificial preserves. The arcadian dream, the rural idyll, even the grandeur of nature in her most supreme efforts are too far removed from the technological environment to allow landscape as subject much sway over contemporary emotions. Therefore, we must understand that it is used today not so much for *what* it represents, but for the *way it is represented*, an exploration of artistic means, of the signs and signifiers of the artist's language. In trying to make abstract form coincide with the representation of an image that exists in time and space the artist has a rich terrain for examining artistic problems and philosophical questions and the points where they intersect. When Wolf Kahn says that he paints landscape because for him "it is the least worn out of subjects," he implies that today it is the least susceptible to interference from prior associations and interpretations. For him it is a vehicle to test further his observation of the emotional

and spatial effects of color interaction, a step further toward the ideal painting in his Platonist frame of reference, and a means to explore the dichotomy that always intrigues him between solid form and diaphanous light.

The latter is an artistic problem that concerned many painters of his generation, but it might also be considered as reflecting a personal anxiety over seemingly unreconcilable opposites based on early experiences that must certainly have left deep-buried insecurity and doubt. The pages that follow will attempt to show the ways in which the landscape paintings of Wolf Kahn are a fusion of general contemporary artistic trends and persisting themes of autobiography. In his own words: "Art turns out to be self expression in spite of your best intentions."

Wolf Kahn, *Brattleboro, Vermont, 1980*

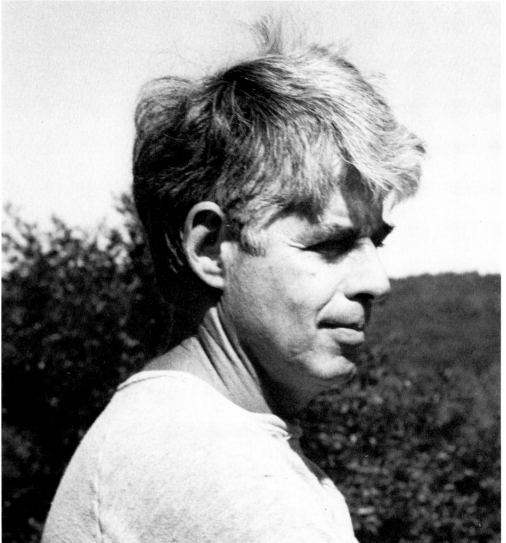

Photo: Emily Mason

Wolf Kahn

Denn das Schöne ist nichts als des Schrecklichen Anfang, den wir noch grade extragen. (For beauty is only the bearable edge of a knowing we could not endure.)
RILKE, *First Elegy*

Explaining the angels in the *Duino Elegies* to his Polish translator, Rilke wrote: "The angel of the Elegies is that creature in whom the transformation of the visible into the invisible, which we are accomplishing, appears already consumated."

Logic tells us that the painter of landscape is transmitting the visible, but one may see the process in reverse and imagine that in bringing the specific toward the general he is moving toward the invisible, i.e. from the material to the spiritual. The artists who came to maturity at mid-century inherited, sometimes uncomprehendingly, the pursuit of the spiritual embarked on by Rilke and his contemporaries, who sought to strip away material appearance. While Rilke chose angels to represent this state, painters sought ideal form, the perfection of geometry or of pure spectral color. Some artists preferred to retain the illusion of appearances and to make it coincide with ideal form. When Wolf Kahn makes a painting in which a band of yellow is both a hillside field and a hovering screen of light he approaches this transformation of the actual into the intangible. Beneath the surface appearance of a Vermont pasture lurks the German Romantic cosmic nostalgia, just as underlying Kahn's forty years in the United States and his solid family and professional life are the early traumas visited on him by that same Germany that nurtured him culturally.

Wolf Kahn was born in Stuttgart in 1927 into a family in which there was a tradition of artistic involvement, along with financial resources that eased the way. His father, Emil, was a composer and conductor of the Stuttgart Symphony; there was a great-uncle who was an artist, as well as a banker in each generation to look after family assets. Being an artist then could be regarded as a natural, respected choice of profession, not an act of rebellion or heroism as it was for many Americans of his generation. The family musical tradition leaned toward romantic lyricism. Emil Kahn's Symphony No. 1, although written shortly after World War I, has no trace of the atonalism or harsh expressionism associated with that period. Rather it is pure post-Romantic music, closest to Mahler in feeling, and he saw it as reflecting the idyllic early years with his wife, Nellie.

Family life was shattered when Nellie, who was regarded as having psychic powers, took up anthroposophy. When Wolf, the youngest of her four children, was still an infant, she left for Berlin in the company of her anthroposophist mentor. Following a breakdown, she entered a sanatorium where she died four years later.

Emil Kahn's second wife was a young singer who did not take well to instant motherhood and Wolf developed such a fear of her that he was sent to live with his

paternal grandmother in Frankfurt. She was the widow of a banker, a rather "grand lady," he recalls, and he was raised as the center of attention in a comfortable household, with an English governess, and paintings by Thoma and Spitzweg on the walls. There were other relatives in Frankfurt to keep an affectionate eye on him: his maternal grandparents, an aunt who gave him art books and taught him the musical motifs on her piano before the concerts they attended, and Uncle Max, an artist who lived near Frankfurt in the country.

Dahlias "larger than life" bloomed in the Botanical Gardens next door where Wolf was accustomed to wander as if it was a second home, and there was a garden behind the house where he had a small seed bed. Of special delight were the *Ausflüge*, hikes in the Taunus with friends whose parents still had country homes, mountain outings that included a picnic or ended with a meal in a little village. He remembers the *Ausflüge* with a particular sense of loss because they were denied to him by 1938 when Jewish children were forbidden to leave the city on vacation. That summer, to keep himself occupied he made a drawing each day of an episode from Napoleon's military campaigns, inspired by Menzel's "Friederich der Grosse" series. On the cover of his drawing book he wrote the title "1806–1813" and then "Verlag Von Joeden," crediting as publisher the woman artist from whom he took art lessons, "an aristocratic single lady who worked somewhat in the manner of Cézanne." This pictorial chronicle was carried out with a mania for exactitude; no detail of uniform or weaponry is spared and the deployment of troops is depicted with the precision of a military tactician.

Others of his childhood drawings have the same precise logic applied to exotic anthropological subjects, as well as to personalities then in the news such as Hailie Selassi and Jesse Owens, and to a variety of aggressive images: goose-stepping soldiers, Muslims pierced by swords, a man holding a severed head, and 2000 years of German military costume. Retentive powers of observation and a capacity for complex three-dimensional rendering are evident in his sketches of a full orchestra with lively line drawings of conductor and players complete with instruments. There are caricatures of his grandfather asking a tobacconist for 3000 cigars, and of his grandparents moving to a new apartment, followed by a procession of movers, one of whom carries a Picasso painting. The mover's comment, "So ein Kitschbild," reflects the budding artist's awareness of artistic styles, as well as the usual child's prejudice against avant garde art. His precocious talent was made much of by his grandmother and her friends; private art lessons were provided and his efforts were applauded. Additional inspiration was provided by the collections of the Frankfurt Museum, strong in German medieval work, and by the paintings and personality of Uncle Max.

Comfortable, indulged, programmed for success, Wolf Kahn by the age of eleven could be said to have had, in many respects, a happy childhood. Only a few isolated

events pointed toward the threat that hung over him as a Jewish child in Nazi Germany. His earliest memory of the Nazi presence was the student anti-Nazi riots of 1932 when he heard shooting during his afternoon nap and ran to the window to see "figures falling like dolls" in the street. Two weeks before the war broke out in 1939, he was given a number and put on a boat with a group of refugee children bound for England. Not until after the war did he learn that both grandmothers had died in a concentration camp. When his maternal grandmother was taken away by the Nazis, the household maid gathered and kept his childhood drawings and sent them to him at the end of the war.

The Jewish Joint Distribution Committee found families to take these refugee children into their homes. The family that held the number corresponding to the one that had been given to Wolf had expected a waif, not a child of privilege whose arrival was heralded by a large and heavy steamer trunk and a bicycle. When they found that he did not fit the role assigned to him of household menial, the Committee located another home for him with the family of a school teacher named Purvis in Cambridge. The Purvises were not well off themselves, but welcomed Wolf, who did better in this sympathetic environment and soon stood at the head of his class in the English school he attended. At the end of a year, the U.S. immigration law was changed and he was able to cross the ocean to the U.S. to join his father, who had accepted an appointment at Montclair State Teachers College and settled in Montclair, N.J.

When his father moved to New York City, Wolf entered the High School of Music and Art where he continued his old interest in drawing and became rapidly assimilated into the life of an urban American high school. One of his classmates was Allan Kaprow who was later to be associated with him in the Hansa Gallery. The School's 1943 Yearbook includes, among topical woodcut illustrations of falling bombs and sailors on leave, a watercolor of Union Square, signed Wolf Kahn. It is a thoroughly indigenous image of solitary men seated on circular steps at the base of a flagpole. The base is carved with reliefs of figures in energetic poses in ironic juxtaposition with the idle men, a motif tinged with the social commentary that lingered on from the Depression years. After school he worked as a commercial artist in an art service near Wall Street and in 1944 he had a cartoon published in the recently founded left-wing paper, *PM*. This marked the beginning and end of the career he envisioned as a political cartoonist.

Following graduation in 1944, Kahn enlisted in the U.S. Navy and was sent to Radio School in various parts of the country. Just before being discharged, he put together a souvenir booklet for the Radio Materiel School in Washington, D.C. which was entirely his handiwork, layout, graphics and illustrations. Having accumulated enough G.I. Bill time for two years of study, he enrolled in classes at the New School with Hans Jelineck and Stuart Davis, but found that Davis, true to legend, was

Stillife in the Style of Braque, 1947
Oil on canvas
28 x 34"
Collection of the artist

more interested in jazz and baseball than teaching art, so he had little incentive to continue. Some small drawings and linoleum cuts of that time show a cautious experimentation with semi-abstraction via geometric simplifications and disrupted contours in keeping with the popular mode of acknowledging cubism in the 1940's.

At this time Kahn lived on 6th Street and Avenue B in Manhattan across the hall from Lester Johnson, a painter from the Midwest some ten years older than he. Enormously impressed by Johnson and the small landscape watercolors that he had brought with him from Chicago, he decided to enroll in the same school which Johnson's teacher had attended. This was the school that Hans Hofmann had transplanted from Munich in 1934 which was then flourishing on Eighth Street and in Provincetown during the summer. There was an influx of G.I. Bill veterans, including Kahn's brother Peter. At the Hofmann School these young men who had experienced varying degrees of upheaval in their lives during World War II, could bypass the legacy of social realism and regionalism for which victorious America, riding the crest of power, had little need. They could partake of the broader tradition offered by Hofmann that grew directly from the mainstream of earlier modern movements in which he had been personally immersed in Europe.

"I went to Hofmann's because that was where the best art students went," is the way Kahn puts it. "He claimed for his ideas a kind of universality which I found congenial to my own need for absolutes. The fact that he was a painter was by far not the only interesting thing about him—his painting was witness to his energy— but he said so many marvelous things and he was a rich, earthy, unpredictable person. I was his studio assistant and we often chatted when we were working together. He didn't want any groupies around, and he had a fear of propelling the students to imitation, but he saw that I took him for granted despite my tremendous admiration, so he talked easily. He was a very profound man."

The most incisive account of what Hofmann offered as a teacher is given by Harold Rosenberg: "Sequestered from time, the School was teaching modern art as a tradition, not any one aspect of it, or school or individual master, but the quintessence present in all, their assumptions concerning space, their investigations of the relation of nature and art, their experience with the suggestive powers of paint, their ideal of the artist as remolder of visual perception and of his own personality. Hofmann's educational aim was to avoid pinning down the student in any style or movement, but to maximize for him the valid possibilities of today's painting. Hofmann had become a teacher to teach not painting, but the conditions of creation in painting."[1]

If there was a Hofmann imprint it was observed more readily in attitude than style. Consider the individuality of Kahn's fellow students at the Hofmann School: Larry Rivers, Allan Kaprow, Jan Muller, Robert Goodnough, Paul Georges, Joan Mitchell. If there is a link, it is in a shared attitude toward the picture plane as the "creative

Early Stillife, *1951*
Oil on canvas
16 x 22"
Collection of the artist

element," the concept of forces generated through color intervals, the rejection of what Hofmann called the "empty affair of painting in two-dimensional rhythms" in favor of a "space that always resounds" and ultimately by the concept of creation as a spontaneous process. This is reflected in Kahn's words: "My attitudes favor a certain amount of blindness; my favorite words are spontaneousness and innocence. Hofmann used to say 'To be in conscious control while you're painting is impossible because there are so many processes.' "

Rosenberg also sees "below Hofmann's analytical approach, a species of animism or fetishism that endowed with independent life every element which the artist handled or contemplated."[2] These elements, the surface, the medium, the object in its space were seen as vital substances palpitating with energies which acted on the artist at the same time as he drew upon them. A picture, then, according to Hofmann, is dictated through the inherent laws of the surface, tempered by the response to elements of the emerging painting. Yet since he kept a low profile as far as his own work was concerned, it is not surprising that there are no Kahn paintings to which one can point and say this was done under Hofmann's influence. His *Still Life in the style of Braque*, 1947, was singled out for praise by the master, even though it had more to do with Braque than Hofmann, but one can imagine him appreciating the assertive brush drawing, the textural interest and especially the unity of all the parts. "The ideal of formal perfection that Hofmann held before his students was that moment in the ongoing process of painting when each element was so adjusted as to exert the greatest influence on every other element."[3]

Today, thirty years later, Kahn's artistic standards are still close to those formed during the time at Hofmann's School on Eighth Street: "Two main ideas emerged for me after I had absorbed enough of Hofmann's teaching to feel that I understood what he was driving at. The first stated that there was a formal logic which governed the masterpieces both of the past and the present . . . Secondly, and related to the first, there was the ideal of the perfect painting, toward which we were supposed to be constantly striving, in which the aforementioned formal logic found its completed expression."[4] The task of the artist was to struggle toward the perfect painting— struggle, with Hofmann, was invariably a term of approbation. And increasingly Kahn's own work became purely struggle. At the end of a week's pose a simple charcoal drawing of the model would be reduced to a "limp grey rag of torn, holey paper" and his paintings would end up after four months with a heavy crust of paint but no nearer completion than after the first day's work.

Although Hofmann himself incorporated automatism into his work and exhibited with the Abstract Expressionists, he insisted that his students paint from life. He might recommend that they see a Clyfford Still exhibition, but the Abstract Expressionist gospel was foreign to their thinking and they tended to regard most of such painting as merely decorative. Students who visited Hofmann's Provincetown home were

Stillife with Onions, *1953*
Oil on canvas
28 x 36"
Collection Horace Richter, Jaffa, Israel

bewildered by the Pollock that was hanging there. It wasn't until the 1958 Venice Bienale that Kahn began to understand Rothko and he didn't appreciate Pollock until he saw his retrospective in Rome. When asked what kept him from plunging into Abstract Expressionism when it was all the rage in the 1950's, his answer was: "I loved to draw. For me representation is central. It's my tradition. Hofmann's most telling lure for me was that you could represent. My friends nearly all tended toward representation. I even thought of Joan Mitchell's work as landscape. Actually the difference between representation and abstraction among all the students of those days was really superficial and not an issue. I remember going to the Club around 1954 when the discussion was about subject matter. Tworkov said it made no difference if you ended up with an object or an abstract image but I said that making one fit the other, taking an object and making a picture out of it, was where the real fun was."

During his second year at Hofmann's School, Kahn was increasingly beset by anxiety over his painting and doubts regarding his choice of career. He had "painted himself into a corner" and was suffering from such a loss of self-confidence that he stopped attending school. He credits Lester Johnson's example of doggedness with keeping him from giving up altogether during that year. Eventually he was so "tied up in knots" that he decided he wasn't a good enough painter to warrant a full commitment to art. To regain some self-respect he availed himself of his remaining time on the G. I. Bill and enrolled in the University of Chicago's "Hutchins Program." There he read philosophy, developing a special interest in Kant, wrote on Cézanne for Ulrich Middledorf and completed the B. A. requirements in one year.

He applied for a fellowship for graduate study in philosophy and decided in the meantime to head west for the summer in a car he bought for $80. His traveling companion was Arthur Brown, a Mennonite ex C.O., and self-taught painter he had met at Lester Johnson's. Arguing about art, they worked their way to the west coast as migrant laborers. Kahn landed a job with an Oregon lumbering operation despite his inexperience, but his friend's eccentric behavior threatened to bring down the wrath of the lumberjacks, so Kahn gave him the car to induce him to move on. It was the time when members of the Beat generation were keeping their jalopies on the move from coast to coast crashing in friendly pads across the country, but Kahn sees his own journey as less desperate, more "like Wilhelm Meister's *Wanderjahre.* I was my own romantic hero." In mid-summer he received news that the University of Chicago had awarded him a full graduate scholarship plus a living allowance. Warily he postponed the decision and responded that he couldn't be back for the fall semester. In late fall he took his $1500 earnings and returned to New York to make another try at painting, and never went back to school again.

The season of 1950–51 offered heady fare to the New York art public, or to that small segment that concerned itself with contemporary or recent art. At the Whitney Museum on 8th Street there was an Arshile Gorky retrospective and at the Museum

Artist in the Studio—Louisiana, *1953*
Oil on canvas
36 x 42" approx.
Present whereabouts unknown

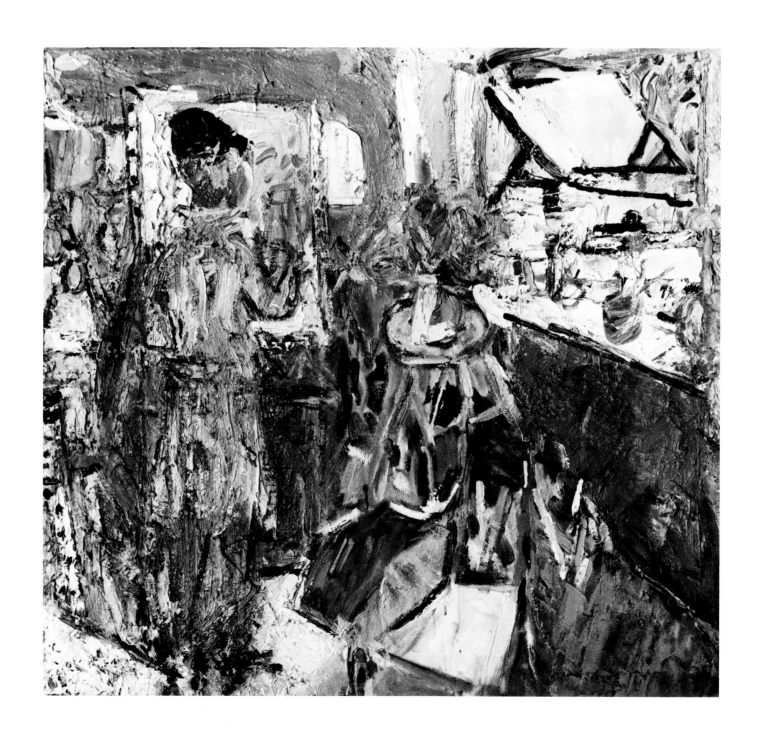

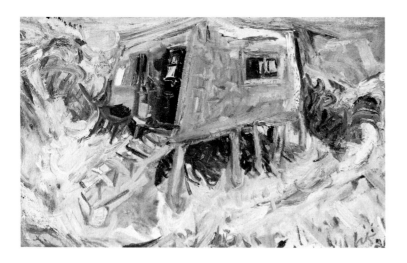

Back Beach Shack, *1953*
Oil on canvas
18 x 26"
Collection Provincetown Art Association

of Modern Art a full-scale Soutine exhibition, followed by a survey of abstract painting and sculpture in America, which featured huge canvases by Pollock and de Kooning, and it was the year of the 9th Street show, forerunner of the avant garde salon, the Stable Annual. For this exhibition the Abstract Expressionists and their friends rented an empty store on 9th Street and hung the walls with a sufficient quantity of all-over abstractions to make it clear that there were not just a few individual practitioners, but a new school of painting flourishing in New York. It was Soutine that had the most immediately visible influence on Kahn, as demonstrated by his *Still Life* of 1951 in which convulsive movement, viscous paint and the troweled canyons and ridges of its surface vividly evoke the hand of the expressionist painter.

However, what set the dominant mood in 1950 was not the work of Soutine or even Gorky or any other single artist. Rather, it was the sense of energy widely ranging over the innovative styles of the previous half century and forging a new synthesis on a heroic scale. This synthesis incorporated Cubism, Surrealist automatism and Expressionist brushwork; it acknowledged also Kandinsky, Matisse, and Mondrian. By the time Harold Rosenberg dubbed this synthesis Action Painting, there were dozens of young artists in Lower East Side lofts and cold water flats emphasizing the process of painting as an act of self-assertion and showing scant concern for the permanence and polish of the final work. Figurative or abstract was not the important question—after all de Kooning started his woman series in 1950 and Pollock began to develop figures in his drip paintings by 1951—what counted was the intensity of physical and psychological involvement in the process. Discussing subject matter, Elaine de Kooning wrote in 1955: "There is no style today not found on both sides of the fence of subject matter . . . The main difference, then, between abstract and non-abstract art is that the abstract artist does not have to choose a subject. But whether or not he chooses, he always ends up with one"[5]

The same writer commented specifically on Wolf Kahn, saying that he was "obviously more interested in the activity of his fierce, separated colors and wild impastos than he is in communicating any particular sentiment about the people and scenes he depicts."[6] The onions in a 1953 *Still Life* are almost incidental, small interruptions of solids in a sea of upward surging brushstrokes. "What we cared about," the artist says, "was paint. We all shared the same delight in paint, Lester, Resnick, Felix (Pasilis), Gandy (Brody), myself."

In December, 1952 Howard Devree, the senior art critic for the *New York Times*, noted the opening of a new "showplace," the Hansa Gallery on East 12th Street. In reviewing the gallery's first exhibition which consisted of paintings by Wolf Kahn, Jan Muller, Jane Wilson and Barbara Forst and sculpture by Richard Stankiewicz, Devree described the work as "characteristically avant garde" and noted that "the least abstract are Wolf Kahn's landscapes, dark and glowing affairs that suggest Soutine." At this time Kahn was already living in the 813 Broadway loft which he

Interior of the Cabin on the Dunes, *1954*
Oil on canvas
40 x 50"
Collection Mrs. Walter Herzfeld, N.Y.C.

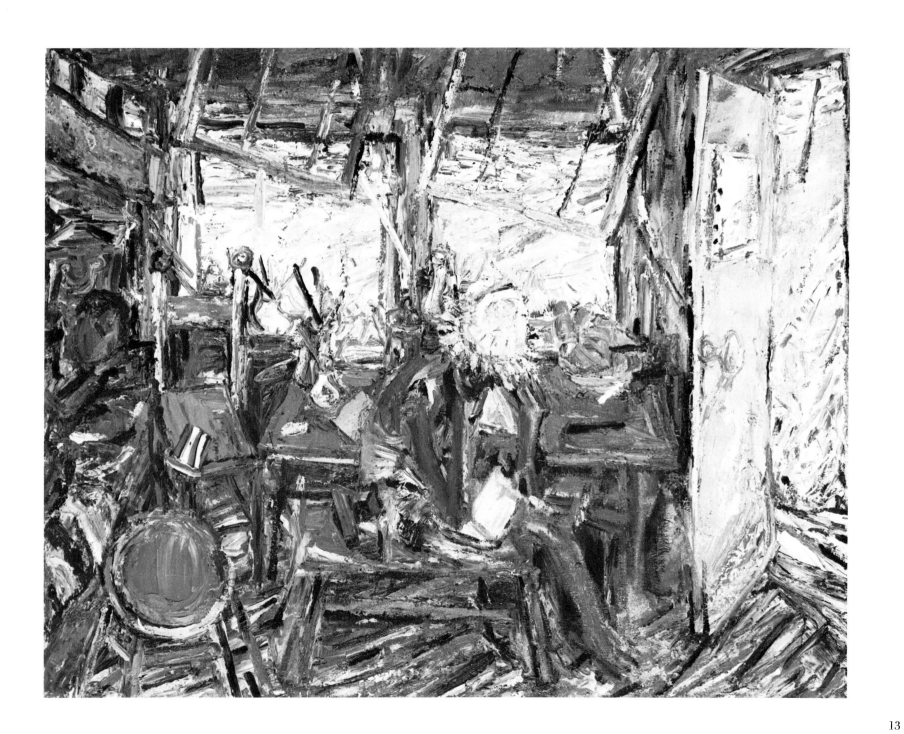

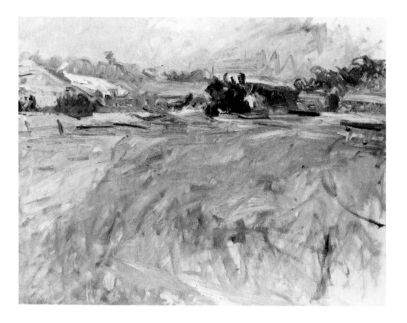

Landscape #10, *1956*
Oil on canvas
25 x 32"
Collection Mrs. E. Katzenellenbogen,
Santa Monica, California

shared with painter Felix Pasilis. Together they hung a show of their work in the loft, as well as paintings by their friends, Jan Muller, Lester Johnson and John Grillo. Out of this grew the Hansa Gallery, one of the most influential artists' cooperatives that flourished along East 10th Street. The Hansa, actually on 12th Street and 4th Avenue, was named after the Hanseatic League, a linking of independent towns for purposes of commerce and mutual advancement.

The gallery reflected the lifestyle of its members, occupying an unpretentious second floor space, swept clean, with its walls painted a fresh coat of white. The way these "loft rats" lived on the Lower East Side in the 1950's was a far cry from the SoHo chic of the 1970's. Many of the spaces were lived in illegally and were mainly workspaces with the barest rudiments for living, even when shared with wives and children. Heated with kerosene or coal stoves, drafty and sooty, they reflected the prevalent anti-bourgeois bohemianism. To care about decor and material comfort could make one's seriousness as an artist suspect. Even to care unduly about art materials might be construed as materialistic. They painted on old bed sheets, cigar box lids and wood from orange crates or, in the case of Stankiewicz, scoured sidewalk scrapheaps for material to weld into sculpture.

Art had priority in the claims made on one's energy and what the artist did for a living was incidental. The expansion of college art departments and the consequent availability of teaching jobs had scarcely begun. They survived through part-time jobs: Kahn as a recreation worker with children in an East Side settlement house and later as a shop teacher, Richard Stankiewicz as an electrical worker, Jane Wilson as a fashion model. Whether one waited table, worked as a museum guard or ticket taker, the overwhelming commitment was to art as a profession and a faith. There was a level of spontaneity and urgency that spilled over from painting into life, from the festive parties in grubby places to the summer bacchanales on the Provincetown beach.

The idea that one could earn a living though painting or be sanctified by inclusion in a museum collection seemed remote. The audience at the co-op galleries was largely composed of one's peers. When a critic or curator came downtown in a rare appearance or one sold a painting to an adventurous collector who came around, such as Horace Richter, Vicci Sperry, or Arthur Mones, it was an event. So it was a most special occasion when Meyer Schapiro visited the Hansa Gallery shortly after it opened and bought a small landscape drawing by Wolf Kahn. According to Schapiro, Kahn phoned him the next day saying that he was honored by the purchase, and that he had a friend whose work he thought Schapiro would find equally interesting, Jan Muller. (Kahn thinks it was Lester Johnson; at any rate he admired both and both were equally in need of money.)

Kahn's first one man show at the Hansa in 1953 was reviewed by Stuart Preston in the *New York Times*[7] who referred to his "leonine manner" and a "brush that might have

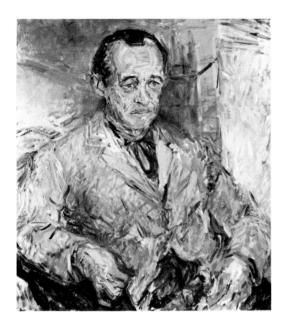

Portrait of Baron W. W. von Schöler, *1955*
Oil on canvas
40 x 30"
Collection of the artist

been guided by a tornado" and by Fairfield Porter in *Art News* who saw the work as "first rate" and suggested that beyond the Soutine manner lay a French-inspired pleasure in color and light.[8] Dore Ashton in *Art Digest* saw a lightening of his palette in a "pervasive brilliance of illumination" and mentioned also his "lyrical pastels and strong naturalistic drawings."[9]

The work at this time made use of the cramped spaces and distorted perspectives characteristic of *Die Brucke* Expressionism. In an almost faceless *Self-Portrait*, the artist is jammed between the angled canvas and the picture plane in an awkward, tension-producing manner. The cabin in *Back Beach Shack* juts a corner toward the viewer while its sides on rickety posts are swallowed in a wild tangle of strokes that carry convulsively from land into sky. The angle where two buildings join in *Arnold's Place* is a hub of conflicting perspectives and the structures burst out of the canvas at top and sides as if the energy were uncontainable. In neither landscape nor interior is there an indication of a space into which the viewer can comfortably project; the image keeps coming up to the surface of the work and the illusion of space is nullified as soon as it threatens to become convincing. The tangible reality is in the substantiality of the paint itself, thickly laid on with brush, pallette knife, thumb or anything handy. If there is an image caught amid these seething marks, it seems more a pretext for the act of painting than selected for its significance as subject matter.

In 1953 a $1000 legacy from an uncle enabled Kahn to quit his job and he joined his brother, Peter, who was teaching in Baton Rouge, Louisiana. He remembers being more impressed by the State Fair than by the landscape, but there is one particularly interesting canvas that survives from this six month stay, *Artist in the Studio*.

It is unusual in that the artist is seen from the back, painting a still life of a vase of flowers on a high stool. The slabs of paint are laid on with such gusto, such emphasis on their push and pull in space, that any section of the work might be mistaken for a detail of a Hofmann canvas. The image of the painter appears caught in the network of brushstrokes, transfixed between the layers of paint: the web of color weaves him into the studio environment. In actuality the artist has stepped back and paints himself at work as someone else might see him, part of a continuity between figure, easel, canvas, still life and working materials. The viewer doesn't share a Matissean seclusion of the artist in the studio or savor, as one does with Bonnard, an exquisite moment in his own interior, rather one is confronted with a kind of symbiosis of artist and work. This image of immersion in the activity of painting reflects the general attitude of the artist toward his work in the early 1950's. Lester Johnson once said, "I am in the painting when I work; sometimes I work with both hands so I am physically more a part of it," and Milton Resnick called one of his large canvases *Storage* because as he put it, "I kept packing everything I physically could into it." The ultimate demonstration of the artist's impulse to charge the canvas with his

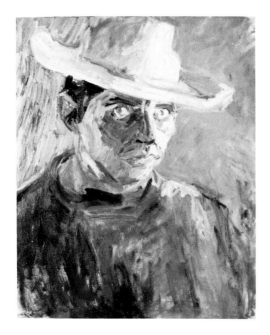

Self Portrait with Sombrero, *1956*
Oil on canvas
20 x 16″
Collection of the artist

own energy had already been caught on film by Hans Namuth photographing Pollock working at Springs. In Existentialist terms, the painting becomes the record of the choice to act, made on the tabula rasa of the canvas.

In addition to self-portraits, Kahn worked on a series of portrait drawings and paintings of fellow artists in 1954–55. His *Portrait of Jim Benton* is still in the Soutine manner, alternately swelling and pinched, but his 1954 *Portrait of Frank O'Hara* is more passive in its tranquil, near-profile pose, and more orderly in the deployment of the brush. Its energy derives mainly from the vibrancy of the shocking pink, purple and orange color. The poet's contemplative role is emphasized by the folded hands on crossed legs, while mobility and complexity are registered in the features by multiple lines that search out the contours and seem to quiver around mouth and eyes.

Another portrait, painted in Mexico in the winter of 1955, was of a German, Baron von Schoeler, a stateless person, a smuggler and alcoholic. The face is twisted and painted in nervous lines of aqua against pinks, violets and oranges with lurid clashes of blue and orange. The man asked him, Do I seem that unhappy that you paint me in such a way?"

"I just paint what's there. I don't know anything about you," Kahn answered.

"In that case I'm in a bad way." In a matter of days, Kahn had word that he had commited suicide in the apartment of the foreign minister and the only address that was found on him was Kahn's.

While in Mexico he painted a self-portrait wearing a sombrero, rather in a Vincent Van Gogh manner, with a baleful look, red ear and face firmly modelled with strokes of bright green and orange. However, the vibrant juxtapositions such as the blue-violet shirt on an orange ground seem to be intended less for emotional power than for the sheer pleasure in getting away with this kind of chromatic intensity. The draftsmanship that he had continued to perfect in his portrait drawings of the early 1950's is manifest in some drawings he made of the local Mexican citizenry, trying to please, as he puts it, some of the "low types" that he knew there. The landscapes of this period are brusque and agitated in brushwork, warm in color, and still characterized by Soutine-like upheavals and twisted perspectives. These landscapes stand out in his Mexican work, opening up his style into a lighter and looser manner; less fraught with struggle than the previous work.

When he had a second one-man show at the Hansa Gallery in February, 1955, he had already established a reputation among younger New York School artists, and critics showed themselves attentive. On the positive side, Fairfield Porter, writing in *Art News* found the work more "Impressionistic and French than Expressionistic." He describes the best of the paintings as having a "solid weight of color and light

Mexican Landscape, *1955*
Oil on canvas
28 x 44"
Collection of the artist

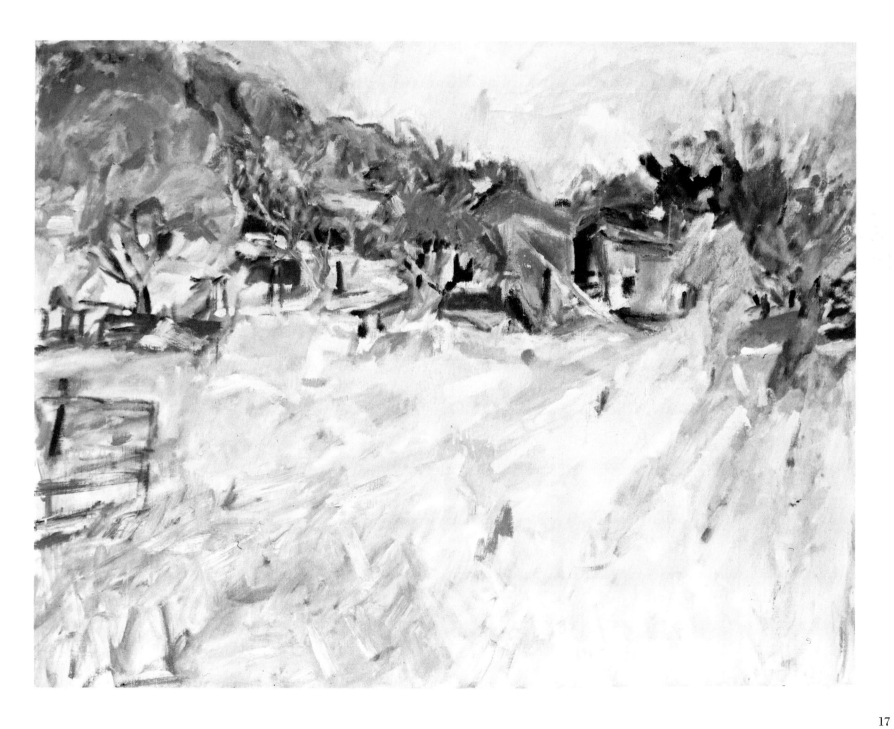

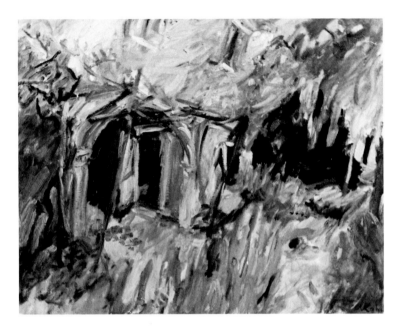

Garden of the Casa Frollo, *1957*
Oil on canvas
28 x 38"
Collection of the artist

in the right place and proportion, making them both heavy and sparkling, miraculously not paradoxical."[10] Hilton Kramer, the editor of *Arts Digest*, wrote:

"What used to be called subject matter is poised here with the palette knife at its throat, facing that abyss where the subject of every painting is painting itself . . . Images are admitted freely in the early stages of the painting, but in the process the palette knife enters and the expressionist slash begins to blot out the fauvesque brush stroke until the long arm of Hofmann's atelier makes itself emphatically visible."[11]

In the 1955 *Art News Annual*, Thomas Hess wrote a lengthy article entitled "U.S. Painting: Some Recent Directions" in which he discussed twenty-one "serious and talented" younger American painters such as Larry Rivers, Helen Frankenthaler, Joan Mitchell, Robert Rauschenberg, Elaine de Kooning, and Leland Bell, and including seventeen artists who had had some contact with Hofmann's atelier either in New York or Provincetown. Kahn was among the painters selected and Hess put him in his third category, those painters who "insist on a greater role for the subject . . . who expect more from the subject they have chosen" and who depend on "precise drawing from nature as a fundamental part of their paintings."[12] The article was the basis for an exhibition at the Stable Gallery and Kahn's *Studio Interior* from that show was selected to represent the show on the art page of the Sunday *New York Times*.[13]

During the same year, Kahn was the subject of one of a series of essays on younger American artists by Dore Ashton in *Pen and Brush*. She saw his work as a continuation of the Expressionist movement, and wrote of his "innate distrust of elaborate esthetics."[14] He was also discussed at some length by Frank O'Hara in an essay on "Nature and the New Painting". O'Hara saw him as "having both the sensibility of the Impressionists,—seeing millions of colors on each leaf and light breaking over a face like foam,—and an extraneous, compelling conviction; his lavishly painted landscapes have the pleasure of a scream from a well-trained soprano."

In the same article Larry Rivers, Grace Hartigan, Nell Blaine, Jane Freilicher and Elaine de Kooning, Felix Pasilis and Robert De Niro were names mentioned by Frank O'Hara as "artists who turn away from styles whose perceptions and knowledge are not their own occasion, who seek their own perceptions and in so doing have turned voluntarily to nature, their way made clearer by the Gorkys and de Koonings which they admire but do not emulate."[15] He then refers, to a talk Clement Greenberg had given at the Hansa Gallery two years earlier, in which he said that abstraction was the major mode of expression of our time, and that any other mode was necessarily minor. O'Hara finds that "for the artists rebelling against this protocol, the elements they retain of the formal structure of the preferred style work for them in an unusually provocative way." This holds true in retrospect; inevitable

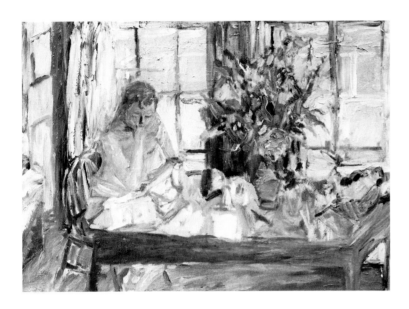

#20, 1956
Oil on canvas
20 x 28"
Private collection, N.Y.C.

borrowings from abstract art, the principle of formal logic on which their artistic ideas were based, the whole abstract frame of reference out of which they worked provided the element of tension that made the canvas exciting beyond the level of routine still life, portrait or landscape. To this day it is the duality of image and formalist idea in Kahn's work that provides its sustaining force.

The handful of artists working from life who, together with Kahn, formed an important nucleus of what was known as the New York School Second Generation were neither in retreat from nor in rebellion against abstract art. Most of them revered the giants of modern art and admired the older New York School artists; however, they were aware of the struggle that abandoning the perceptual image had entailed. They questioned whether the next generation could legitimately adopt the surface appearance of Abstract Expressionism without being in danger of becoming empty formalists. For some the answer was clearly in the negative and they made the decision to renew their work through constant reference to the motif, figure, landscape or still life. As Frank O'Hara implied they were clearly "Post Abstract" artists in that they knew all the formalist issues and made provocative use of them. Prevalent characteristics of their work were the attachment to painterliness and the knowledgeable exploitation of the dichotomy between illusionistic space and the concreteness of paint and picture plane.

In the self-portraits and figures in interiors that Kahn painted after his return from Mexico in 1955, there is a decidedly calmer manner in paint handling, a more stable composition and harmonious color. The back wall of the interior space runs parallel to the picture place, the figures are more likely to be frontal and stabilized and the brushstrokes are firm and ordered. "I tried to express tranquility and contentment with overall lightness of tones, general vertical composition and subdued, dancing brushstrokes" he wrote in 1956.[16]

Despite the Matissean echo to his words, the look of the typical painting of that period is closer to Bonnard, with its translucent layering of color, its glimpse of sea beyond the window and the unobtrusive, but all-important female presence in the interior. Instead of streaks of strident color, clashing with adjacent hues, he begins to apply color more softly in larger areas and achieves vibrancy by the layering of closely related tones such as pink, orange and pale yellow. The interiors painted in Provincetown in the summer of 1956 are close to Bonnard in ways other than color. The female figure that is as integral to a Bonnard interior as flowers and sunlight becomes a part of that summer's paintings. Reading, studying, seated at a table to one side or in the upper middle ground of the painting is a young woman sharing with the objects around her the web of light reflections from the sea and sand beyond the window.

Marittima, *1958*
Oil on canvas
22 x 32"
Present whereabouts unknown

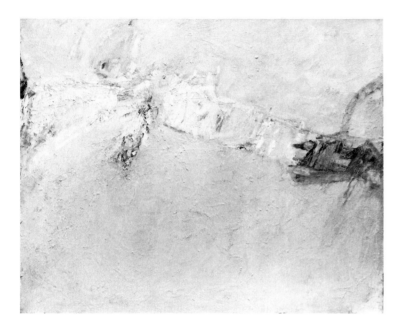

The young woman was Emily Mason, daughter of one of the founding members of American Abstract Artists, Alice Trumbull Mason, and a recent graduate of Cooper Union. They had met at the Artists' Club the previous winter and she had posed for a painting playing the flute. He was sharing his loft at that time with Robert De Niro and feeling rather depressed, and when Emily appeared with flowers at the door of his studio, it broke through the somber mood. They spent the summer together in Provincetown and he describes the paintings that flowed forth in such abundance during those months as a "threnody to Emily." Although he gives credit to Bonnard for the new harmony of color and delicacy of paint handling, he is quite willing to admit that Emily brought her "state of grace" to his life. There is a new serenity and tenderness to these interiors filled with dancing light playing over the book covered table, vase of flowers and small figure. The source of this benign influence had already been awarded a Fulbright grant to work in Italy during 1956–57, but when she left for Europe in the fall, it was understood that he would join her that winter after his New York exhibition.

His letters to Emily in Italy that fall reflect considerable doubt, emotional turbulence and anxiety, as though emotions long held back or expressed chiefly in his paintings had finally surfaced. Meanwhile, the more drastically expressionist elements of his painting, warped perspectives, chaotic brushstrokes, uptilted planes and dissonant color had been replaced by nuanced color interactions, balanced compositions and steadier, less vehement paint application. There was a growing affirmative response to his work: the Museum of Modern Art acquired a pastel for its permanent collection; one of the successful uptown galleries, the Borgenicht, took him on and his third one-man show was held there in December, 1956, and *Time* magazine printed a color reproduction of his *Late Afternoon,* 1956, as part of a story on younger artists who "bear watching." (Others were Rosemarie Back, Helen Frankenthaler, John Levee, Jan Muller and Robert Andrew Parker.)[17] For Kahn at thirty, success seemed assured. "I wasn't ready," he says in retrospect. "I ran away."

This remark should be seen in the context of the 1950's when few artists had expectations of success, and certainly not by the age of thirty. The major Abstract Expressionists had been close to, or over forty when they began to sell paintings or to be noticed by museums. The next generation inherited the idea that a long maturation process and period of struggle were inherent to being an artist. Kahn seems to have mistrusted his early triumphs or feared that he might be trapped by success before his art was ready. He left New York and joined Emily Mason in Venice where they were married at the Palazzo Loredan in March, 1957. This marks the end of the overtly expressionist phase of his art. By the time he returned from Italy his work had undergone a major change.

In Venice he lived on the Maritime Canal where the milky light began to affect his work and move him in the direction of tonal painting. However, the first few landscape

White Light on the Water, *1960*
Oil on canvas
53 x 82"
Collection Mrs. Gustave Levy, New York

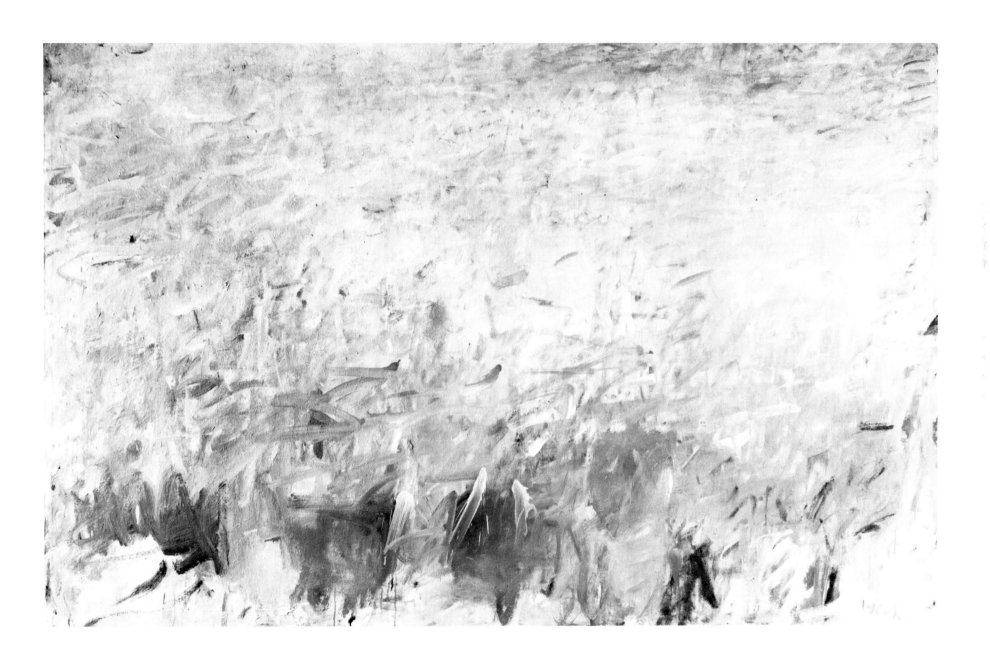

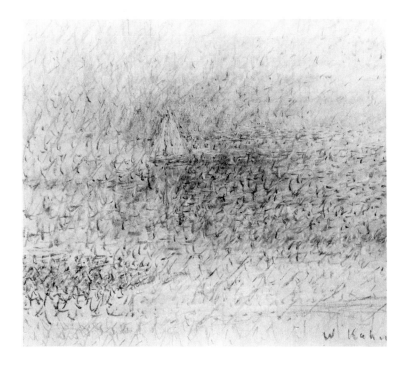

Sailboat, 1956
Pastel
13½ x 15"
Collection Mr. Horace Richter, Jaffa, Israel

paintings done in Venice, such as *The Garden of the Casa Frollo*, hark back to the freely brushed, undulating Mexican landscapes. "I think," he comments, looking at these works, "that I was just trying to reestablish my identity in a strange place by recapitulating earlier styles. A lot of artists do that when they change locale." By 1958 muted greys and softly tinted whites had replaced high keyed color. *View over a Plain*, painted near Pienza in Tuscany is a key transitional work with its tones of warm white, green and grey, and a horizon so high that the landscape is almost like a curtain lowered over the surface. It is at this point that the surface, with its buttery slabs of paint assumes a greater importance than the spatial tensions generated by the push and pull of color planes.

In addition to responding to the change of light, Kahn was also beginning to have a different relation to abstract expressionist painting. It was at the Venice Bienale in 1958 that he first began to respond more fully to Rothko whose work he had previously regarded as merely decorative. He started to think about "doing Rothko over from nature." Although he had always liked de Kooning and Gorky he found that he responded to the work of Guston and Pollock as well. Whereas in his portraits and his Mexican paintings he had been quite clear about what he wanted to do and how to go about it, in Italy he felt, for the first time, uncertain about the direction he wanted his work to take.

The last work he did in Venice, *White Painting with Boat*, is endowed with a Whistlerian softness and nuance of tone, yet at the same time it is heavily textured, with a dense layering of painterly gestures and marks of struggle and indecision that constitute a narrative of the painting process. As with Action Painting, this textural density had to be personal and bound up with the painting's evolution, as if there was value added by evidence of energy invested.

While living in Spoleto in 1958 he painted a double portrait of his artist neighbors, Gretna Campbell and Louis Finkelstein. Dissatisfied with the painting, he turned the canvas over and used the other side for a landscape. Whether or not he realized it at the time, it was a symbolic turning over of a new leaf. Landscape was henceforth to be his exclusive subject matter. With the exception of occasional drawings and pastels of his family, the figure disappeared from his painting. One can hypothesize both personal and artistic causes for this change. From this point on actual people, his wife and daughters, were secure presences in his life. In the close quarters in which they both lived and worked, there was the constant reassurance of another person at hand, consequently less need to fix that presence on canvas. More significant as a factor in the shift to landscape is his growing interest in light and a kind of tonal painting more appropriate to spaces than to volumes. Representing the figure still involved his old expressionistic interests whereas now, partially inspired by Guston and Rothko, he had developed a preference for tonal contrast and form dissolved in

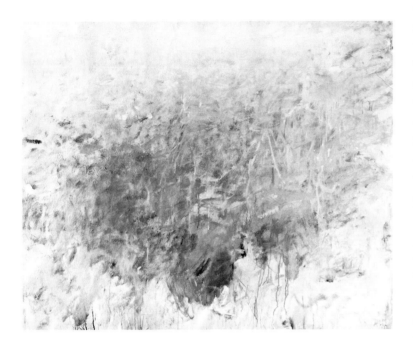

Atlantic Highlands, *1960*
Oil on canvas
44 x 53½"
Present whereabouts unknown

light. He chose his subject because of its suitability for the painting problems that absorbed him.

When he returned to the U.S. in 1958, he brought with him predominantly grey Italian paintings which were shown the following year at the Borgenicht Gallery. Although the paintings did not sell well and the show did not generate the same excitement that had greeted his earlier work, he persisted in the direction of increasingly somber tone and heavy surfaces. The decade that followed was again a time of struggle in his work—the paintings came slowly and with difficulty. It was a period of personal adjustment and straitened financial circumstances, with the arrival of children and both parents trying to live and work in the Broadway loft. He seems to have had a conviction that if he was to grow as an artist, he must do something he couldn't do easily. Since childhood he had been praised for his drawing and painting facility. It may have been necessary for him to go into an area where facility counted for little in order to prove himself in terms which he felt were more profound than those of his early success.

Places, too, had their effect. They spent three summers on Deer Isle off the Maine coast and another three in an old house in the woods on Martha's Vineyard, and six months in San Francisco while he was a visiting artist at Berkeley, all of them places which heightened his awareness of the nuances of light and atmosphere. He began, Turner-like, to work in layers of paint which seem to entrap light so that it reflects from beneath the surface. Characteristic of his work of the early sixties is *Atlantic Highlands* with its traces of many gestural marks, flurries of painting activity and drips running down like fringes from curtains of paint over the ridges of impasto. Somewhere within the over-all surface activation, the landscape image lurks. Ghosts of wharves, distant bridge girders, watery reflections and a high horizon gradually reveal themselves through the screen of brushmarks in *San Francisco Harbor*, 1961. Similarly, the faint presence of a sailboat hovers amid screens of closely related tones, softly applied and densely layered, in *Stonington Harbor* of the same year.

It was fashionable in the late 1950's to find an ancestry for Abstract Expressionism in Monet's late *Waterlilies* which had been placed on view at the Museum of Modern Art and which was described by Louis Finkelstein as looking like something hot out of a New York Studio.[18] Such a comparison was superficial at best and disregarded Monet's intentions and the abiding importance of the motif in these works. For Monet it was necessary to confront the specific in order to transcend it, but if an image lodged beneath the swells of Action Painting it tended to have symbolic or mythic rather than perceptual origins. Kahn's paintings of 1959 to 1962, based as they are on the perceptual experience, are closer to the organizing principles according to which Monet fused water, floating lilies, reflected sky and land, into one shimmering screen of light, than are the bravura gestures of the Action Painter. Although his coastal paintings differ chromatically from those late Monet works, there is a similar

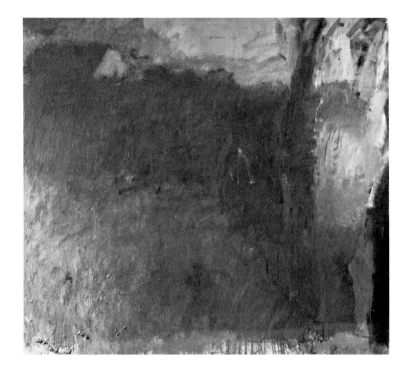

Romantic Landscape, *1966*
Oil on canvas
50 x 43"
Collection of the artist

concern for a surface density that has the capacity to increase or alter light through refraction.

By 1962 when he painted *Lands End* the layers of relatively soft brushwork and pervasive luminosity had congealed, solidified into thick, inpenetrable surfaces with obdurate vertical divisions of tonal zones. "At some point," Kahn says, "I began feeling that I didn't have the equipment to really deal with what happened in nature, that I needed to simplify in order to strengthen. My works got heavy and grey and black because I didn't know how to get what I wanted." Looking back on the canvases from the mid-1960's, he speaks of being stuck on one or two problems, but adds that it was probably useful to spend years doing this kind of painting because "one gets to know what an artistic problem really is."

In 1963–65 Kahn was awarded a Fulbright scholarship and returned to Italy. During this Italian sojourn he continued working on the problem of equalizing positive and negative spaces in a series of paintings of trees. Forecast in the vertical break in *Lands End*, the uncompromisingly straight bands of tree trunks are simultaneously part of the surface skin while still distinguishable from the intervening spaces. At times the negative space comes forward and the trees appear to recede in an ambiguous interchange. In *Tree Curtain* of 1964, the image stops two inches short of the lower edge and drips of paint run down the remaining strip of canvas like fringe from a heavy curtain. This device marks the start of that lifting effect usually achieved by leaving a wedge of bare canvas at the lower right, a stratagem that continued to be a hallmark of Kahn's paintings, as a warning not to lose oneself in the landscape illusion and a signal that one is confronting first of all a canvas with marks of paint. "I want the painting to be like a windowshade pulled down over the surface," he states. He recalls Robert Moskowitz, who actually glued a windowshade to the canvas at one stage of his career.

The second Italian sojourn was not an easy time for the artist. Living in Milan, separated from the well-wishers who surrounded him in the United States and having the concerns of a man with a family, he went through a period in which it was again almost impossible to bring a work to completion. Even when offered $1000 for a painting, at a time when it was desperately needed, he couldn't bring himself to stop working on the canvas and consider it finished. Looking at these works with a touch of antagonism he recently said; "I painted on those paintings for months. I wanted to do all kinds of incompatible things, like make a very atmospheric painting and at the same time be very solid. Even though they look dark, I never used black in these paintings, but a combination of purple and green for black and a Winsor-Newton blue-black to make a really silvery grey."

Years later, in a talk at the New York Studio School, Kahn quoted a passage from Robert Henri's *The Art Spirit* which he must have found particularly pertinent to his own painting experience during the 1960's.

Land's End, *1961–2*
Oil on canvas
25 x 45¾"
Collection Mr. & Mrs. Jerry Shore,
Sands Point, N.Y.

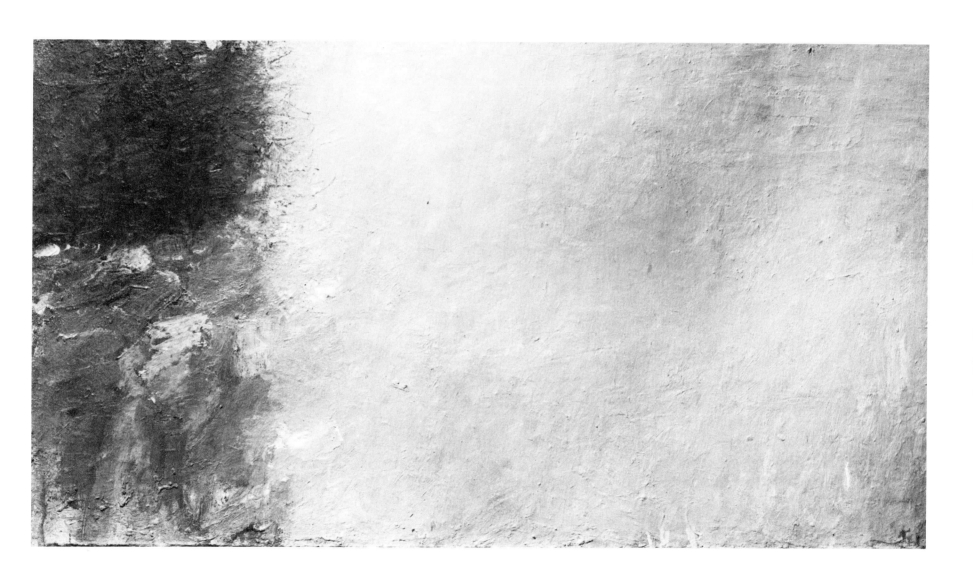

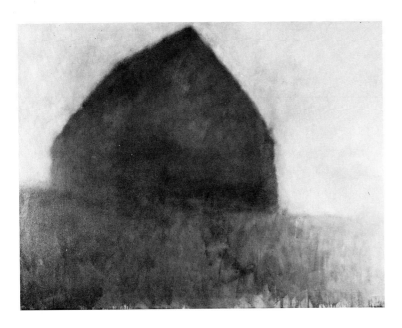

Looming Barn, *1968*
Oil on canvas
48 x 64"
Collection Suzanne Vanderwoude

"The object of making a picture is not to make a picture, however unreasonable this may sound. The picture, if a picture results, is a byproduct and may be useful, valuable, interesting as a sign of what has passed. The object which is back of every true work of art is the attainment of a state of being, a state of high functioning, a more than ordinary moment of existence."[19]

In these uncompromising Italian works the static compositions are not countered by the enlivening tonal shifts or felicitous brushwork that graced his previous work, but there is a provocative combination of solidity and elusiveness to these tree paintings, such as *Edge of the Woods*, 1964. The weighty presence of the understated image has a slowly compelling and mysterious quality generated in part by the contradictions between the density of the paint and the virtually empty lower rim, and in part simply by the evidence of long struggle that is imbedded in those leaden surfaces. The fact that he was in Italy seems to have been of little consequence in terms of effect on his work, since the problems he was grappling with were those he had brought with him. He had friends among Italian artists, Scanavino, Strazza, Vedova, Marignoli, Leoncillo, but he never met the one for whom he had the most profound admiration, Morandi.

Back in the United States, spending the summer of 1965 in Martha's Vineyard, Kahn once more turned to boats at anchor, the slender masts replacing the trees as vertical dividers. He continued to use the slabs of heavy paint, sometimes crudely drawn into with a palette knife, the drips and scumbles and the quasi-geometric divisions of the canvas, the slight lift at the lower rim and the glimpsed layers of underpainting. Always a little more relaxed when working on a small scale in pastel, Kahn achieves with fluency in *Offshore*, 1965, the effect he aimed for in the more laborious oils. This work conveys the impression of emptiness and nuanced light with solids impinging on the delicate atmosphere; a frail cluster of masts, a sheen of light on the water surface and a dimly perceived shore glimmer through the translucent layers of pastel.

In 1966 when he spent a second summer on the Vineyard, in Oak Bluffs, in an old farm house surrounded by dense overgrowth, he began to be aware of the hulk of the barn and to bring its dark shadow into his tree paintings. *Barn in the Woods*, 1966, is the harbinger of an increased complexity, an opening up of space through the contrast of the dark mass with the relatively lighter, more open wooded area on the left. There is also the drama of the barn's presence, something definitely there, but suggested by tone more than defined as a shape. This intrusion marks the introduction of a motif that continues to fascinate Kahn fifteen years later, how to paint a large solid form without having its volume destroy the diaphanous effect of the painting. From this point on, a building appears more frequently in his paintings, poking up over a high horizon in *Romantic Landscape*, 1966, lurking within the fog in *Looming Barn*, 1968, jutting a corner through the trees as in the 1968 pastel, *Corner of the*

On the Water, *1965*
Oil on canvas
30 x 38"
Collection Mr. & Mrs. Benedict Lubell, Tulsa

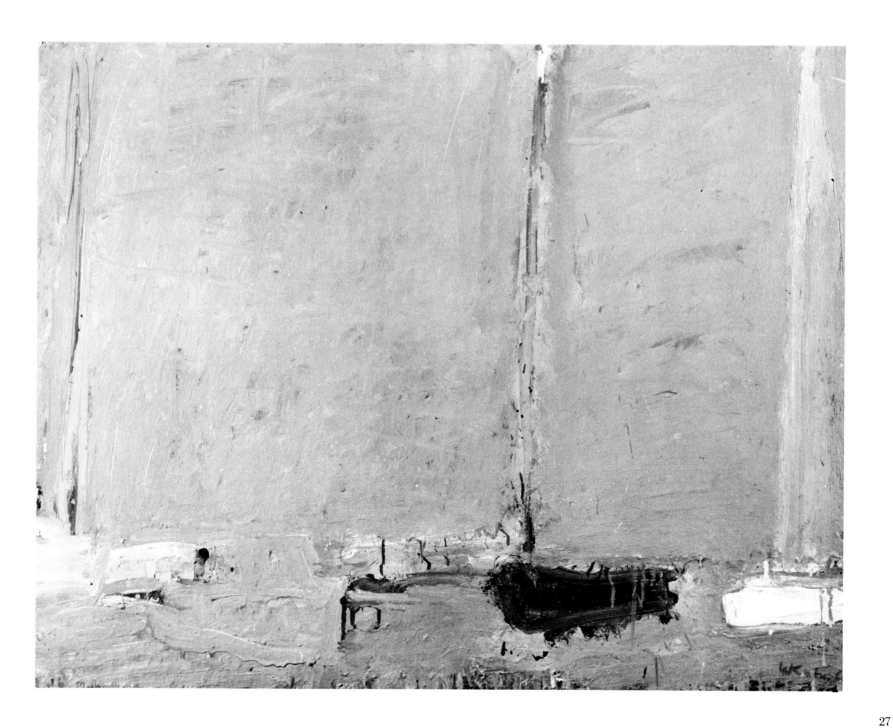

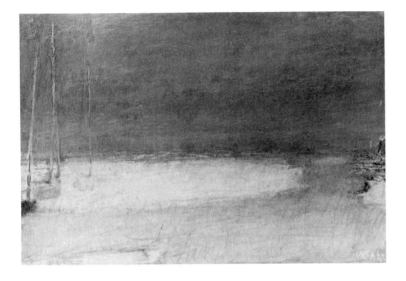

Offshore, *1965*
Pastel
11½ x 17"
Private collection

Barn. With the introduction of the barn, the landscape image returns more overtly to Kahn's painting, in the traditional sense of an illusionistic space, in which there are specific objects ranged from foreground to distance. However, his subsequent work retains from the period of the 1960's a structure of broad, simple areas, instead of Expressionist clutter, and the telling marks or lacunae that prevent us from being deceived by the illusion.

The first few years after the return from Italy were particularly hard financially. Both Wolf and Emily were trying to paint in the Broadway loft as well as using it as living quarters for themselves and two young children. Kahn developed an ulcer which eventually prompted him to endeavor to cultivate a more relaxed attitude toward his work. During 1967, Meyer Schapiro, knowing of his economic difficulties, arranged for him to be commissioned to paint portraits of the senior faculty of the Jewish Theological Seminary. A double portrait of Dr. Louis Finkelstein and Dr. Saul Lieberman was successfully completed and shown at the Jewish Museum. Two other portraits were finished and then the project was dropped.

Ten years after he had become involved with tonal painting in Venice, Kahn finally got back to color in Maine in the summer of 1968. He attributes this return to color to the western exposure of his studio which allowed him to see the sunset every night. *Yellow House, Maine,* 1968–69, combines tonal painting with a chromatic approach; there is a patch of yellow at the lower right with grey and violet drips running over it and the house is a decisive bright spot with echoing vibrancies around it. This was a clear turning point which led into the brilliant chromatic paintings of the succeeding decade. The mists dropped away and color became the fundamental structural element. At the same time he abandoned the coastal locales that had inspired his atmospheric works and moved to the hills of Vermont, acquiring a farmhouse and barn precariously lodged against a sharp slope with a command of a valley that stretches away toward the distant Green Mountains.

Surveying the paintings that Kahn has produced in the years he has owned this farm, one imagines that he chose it out of temperamental affinity, not merely because it was, as he asserts, available and he could afford it. The extraordinary aspect of the Kahns' farm from the standpoint of his art is the difficult terrain, with diagonal pulls in all directions: the row of trees edging the slanting back field, the steep slope dropping away to the valley and the vast sweep toward the low-lying mountains on the horizon. Simultaneously one is aware of the looming shadowside of the barn. To work poised on such a dynamic site between the downward and upward spreads of land, experiencing the tension between gravitational forces and resistant masses, must in itself be a stimulus.

Since they bought the Vermont farm, Wolf and Emily Kahn have traveled very little except their routine move back to New York where they still live in the winter.

Standing on the prow-like porch, back to the view, he says, "You live in a place and it composes itself into visual clusters; you let the familiar jell for you until it becomes an image. An image occurs when things come together so that they have an hierarchic arrangement in which each part sets off another part in some kind of order." He tends to choose a "visual cluster" for the problems it poses. Hence, the hub of varying perspective lines at the intersection of two wings of a building, or the uncompromisingly flat broadside of a barn or the jutting corner of his own barn as it slants off down the hill, or the formlessness of a sandpit, each chosen for the challenge they offer. In an almost puritanical fashion the artist tries to avoid a view in which there is too much risk of the picturesque and to ensure that there will be the stimulus of difficulties to be overcome. Since he purchased the Vermont place his paintings have almost all been based on terrain within a few miles' radius of the house, as if he knew where to find the problems that might elude him if he were traveling through new territory. This may also be ascribed to the need for stability which he admits reaches almost pathological proportions for him, a yearning for roots, a desire for the absence of conflict.

The urge for continuity is apparent in his reluctance to change his studio of 30 years, even for far better space, the fact that he has had the same N.Y. dealer, Grace Borgenicht, for a quarter of a century, and the same dealer in Houston, Meredith Long, for twelve years. For the same reason he derives satisfaction from routine chores, building the fire in the wood stove used for cooking, planting flowers and vegetables, harvesting, freezing produce for winter, cleaning a fish, preparing a soup, as if all these were strands in the web of security he seeks to weave for himself. When there is a party in his fourth floor apartment overlooking Stuyvesant Square, at Christmas or after an opening, he turns his hand to the food preparation, and dances strenuously among the old friends and associates who may be found there year after year.

Old loyalties, continuity of place, friends, work habits and close family ties provide ballast for the lonely voyage that an artist undertakes. Kahn is a participating family man, with strong ties to his daughters, Cecily who is an art student and Melany, a student at Bronx High School of Science, who regularly comes to the studio to help him with framing after school. Recreation is likely to be music, singing with the chorus at the nearby Marboro Music Festival in the summer, attending concerts in New York in the winter, and enjoying the company of musician friends. These activities complement a nine to six work schedule and provide the predictable and familiar pattern of life Kahn prefers. The excitement comes from painting. "An artist," he says, "is unlikely to lead an adventurous life; he stays in his studio and looks out at the spectacle."

Although teaching has not been a part of his routine in recent years, he did teach at the Cooper Union Art School over a sixteen year period and continues doing shorter stints as a visiting artist at other colleges. He found that teaching made him

extremely nervous, and with his characteristic doubt he wondered, "who am I to tell others what to do when I'm not sure of it myself?"

Fields, barns, glimpses of the Connecticut River, the comfortable scale of the Vermont landscape, the haze where woodland meets open space have been the recurrent subjects of Kahn's painting during the 1970's. While non-painterly styles such as Minimal/post-Minimal, Conceptual and Photo-Realist movements claimed a disproportionate amount of critical attention during the decade, he persisted in directing his eye toward nature and leaving the visible marks of his fluent and often graceful brush on the canvas surface. It is difficult to divide this most recent body of work into phases because the changes took place gradually and imperceptibly and the images remain constant from one year to the next. However, if one compares similar works from early and late in the ten year span, there are unmistakable differences. The major changes are in the greatly increased complexity of space and in the range and power of color.

A barn of 1979 compared with a barn of 1969 will prove to be painted more thinly and in purer hues; the former will offer more specific detail and a more difficult perspective system will be called into play. A view of a field from the early 1970's usually has the access to the distance cut off by a dense and opaque hedgerow. By contrast in the recent *Upper Pasture III* the bright yellow field lies near the top of the canvas, beyond the dark middleground row of trees, leading the eye away from an uneventful foreground toward both heighth and depth. Whereas his early trees and barns had been massive shapes on the surface, they now hover in the middleground and increasingly the view penetrates to a considerable depth. The lower edge of the canvas still remains empty. Unlike the 18th century landscapist who was instructed to anchor his composition with a foreground "offskip," Kahn likes to float his view so that even the broadside of a barn tends to appear suspended in space. That virtually empty edge is one of the devices that enable him to paint a solid form and still retain a floating, color-field quality.

Further stylistic changes can be observed in comparing *Powerline*, 1969 with *Riverbend* of ten years later. A head-on view of a central straight cut through the trees makes *Powerline* a simple, static composition that harks back to the *Tree Curtain* series, although it is softened by the hazy grey layers of paint. The planar emphasis has disappeared in *Riverbend*; an obliquely viewed straggling procession of trees sweeps diagonally down toward the viewer while river and road, slanting in from opposite sides, head toward a center convergence. In the newer works there are passages of loose brush drawing, dragging the paint drily across the surface. The paint is also applied in translucent layers with glimmers of bright underpainting, as opposed to the heavier, more opaque pigment of ten years earlier. Less dependent now on a single dominant shape or direction or on laborious reiteration of form, he

Barn in the Woods, *1967*
Oil on canvas
53½ x 67"
Collection of the artist

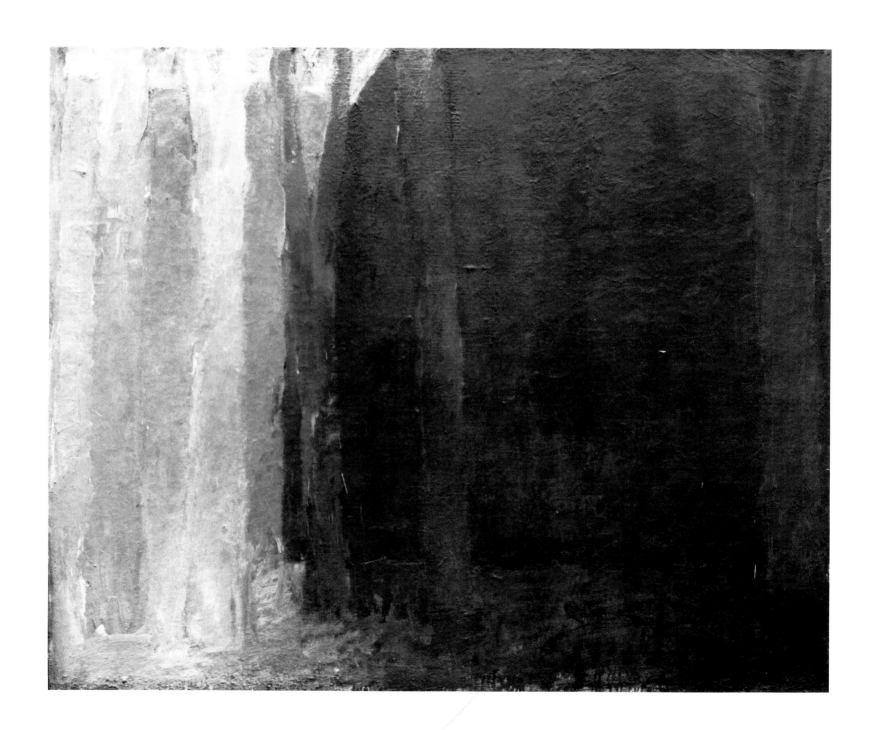

Power Line II, *1968*
Oil on canvas
36 x 42"
Collection Smith College Museum
Gift of Maurice Vanderwoude

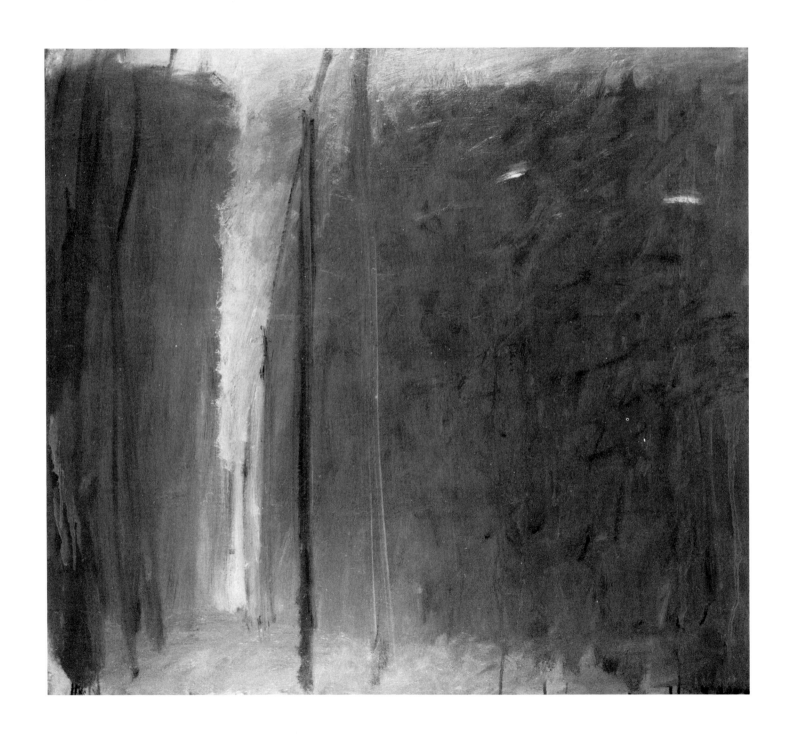

opens up a spacious terrain with confluences of variously angled slopes and he selects color with a boldness that harks back to his portraits of 1954.

Since 1970 paintings have flowed from Kahn's brush with a steady momentum. Previously with great effort he had completed some fifteen canvases a year whereas he now can often finish a hundred. He has stopped "making a pitched battle" out of every canvas. No less nervously alert to the sensory responses that might hold the key to a painting or to the possibilities of a new idea, he simply has developed a process that works well for him. In Vermont between June and September he starts as many canvases as possible directly from nature. He brings these back to New York, to the environment in which he thinks his paintings grow best, Broadway and 12th Street, where he claims to "see nature most clearly, undistracted by trees and skies."[20] There in the lair he has created for himself during thirty years of occupancy the idea takes over and perception merges with formal concept. However, despite the studio finishing process, the sense of time and place is vividly present in the final work, perhaps even sharpened in recollection.

In order to observe the interaction between the artist and his subject, the writer accompanied him on a painting outing in Vermont on a day in late September. The following notes made on the spot give some sense of the place and process:

We are off in the car on a painting outing, stopping at the bottom of the hill to leave a box of candy for a neighbor's boy who has had a head injury. It's a real rural slum, a partially finished house with cinderblock and plywood additions, sheds in various stages of dilapidation sprawled between field and trees, innumerable broken tricycles, scooters, rolling stock of various kinds, tires, oil cans, unhitched wagons, an old silver trailer with windows missing, crumpled aluminum and plastic furniture; plastic trays, a few geraniums, chickens, collie-type dogs, three horses . . . A few miles away we turn into an old logging road, a rutted dirt road, park the car and walk into a field. "This is the anxiety producing moment; where to paint. I like something with construction, that barn from this angle, with its dark side. What I really came out to do was a certain burnished copper quality that you get this time of year. I'd like to paint Hercules Seghers in 20th century dress. He gets a bronze quality I like. See those two grey structures down the hill, everything composes around them; a crutch that enables you to be very exact, position gives orientation, but now up the hill is much more difficult, nothing to orient you. You have to be a great artist to paint that." He prowls nervously through the waist-high grass, disturbing a hawk who flaps off over the field. It's an absolutely clear day, a few brushed clouds to the south but the rest of the sky an untroubled blue. The Queen Anne's Lace has turned brown, the thistle blossoms have turned to down and pale yellow milkweed pods dapple the grass.

"Down the hill toward the sun is almost too bright, so contrasty. I'm in a real quandary; whether to paint a big empty painting or a small busy painting. It all depends on

33

The Bullock Farm, *1977*
Oil on canvas
42 x 52"
Collection Pam & Henry Cimetta,
Saddle River, N.J.

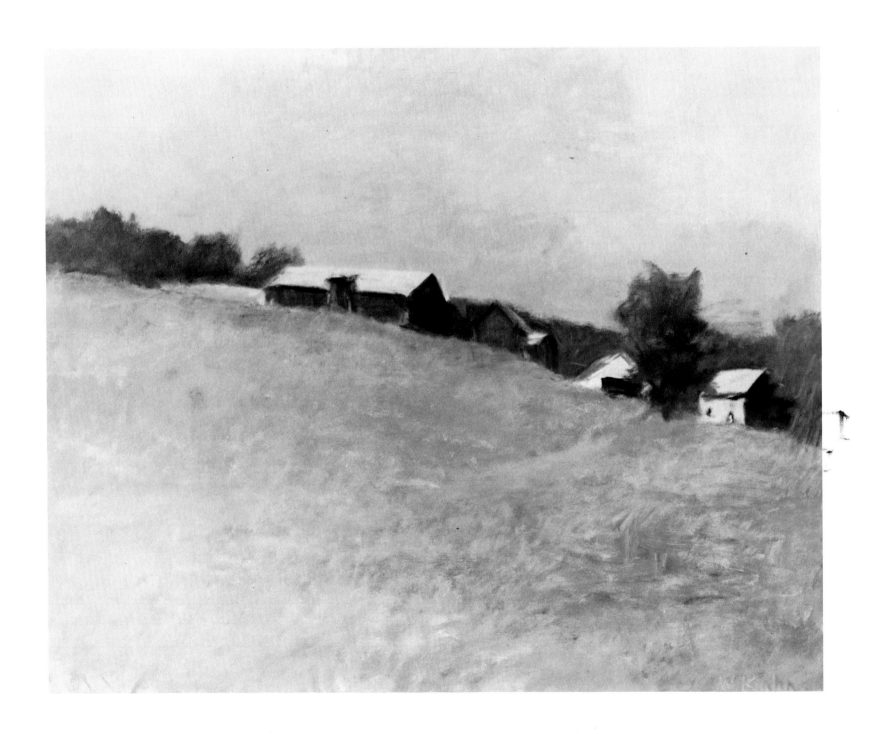

whether I look up or down the hill." The portable easel is set up in a compromise position and a smallish canvas is placed on it, but then he leaves it and plunges off into the grass and the pacing continues. The grasses are almost unruffled. The stillness is not really total because there are crickets, a little wind through the trees on the far edge of the field and sporadic bursts of distant chain saw noise. He has put on special sunglasses that change the light but not the color. "Within the context of old-fashioned procedures I use all sorts of technological aids, all these stable aniline colors which did not even exist in 1940. I start out with my most brilliant color right away."

He takes a wide brush and lays on a green that looks almost gold in a wash made with pure turp. Oil will thicken the medium in succeeding layers. There is the sweet smell of the grasses and the energy seeping in from the sharp autumn sun, low in the sky for late morning. His movements are quick, the brush scrubs over the canvas; his head turns constantly toward the downhill view. The yellow of the field and spottings of turning trees goes on first and purples follow. A whitish bluish streak establishes a direction for a cloud. He has chosen the downhill view which is more complex and more spotty. He likes those anchoring buildings, but they do not go in first. His head turns constantly back and forth; the reference is important. After about ten minutes he steps back a few feet to look.

The barn emerges, its roof glint is a patch of bare canvas. The longer one faces that light the darker the shadowed surfaces become. Nestling in the field the tiny asters are higher than the head and everything except the sky is seen through a screen of grass. The question comes to mind: Is it possible to paint the landscape and also enjoy it?

"I can't enjoy the landscape the way an ordinary person can because I'm too anxious. After painting the other night I looked around and made the startling assessment that it was a beautiful evening." While working he keeps about six brushes in hand, cheap ½″ and 1″ decorator brushes, long haired brushes that make it possible to go over an undercoat without scraping it up.

The old orchard on the cleared hilltop is already bare and winter lurks in the shriveled leaves and brown stalks among the green and lavender-grey grasses, but summer's last great gasp of glory goes on, the milkweed pods ripe but not yet burst, the blackberry leaves copper. The painting has taken shape—lavender and pale yellow streaked with rose in the foreground; a peach tone beyond the middle row of grey dead tree skeletons. A tall pine is blackish green against the light. He has used his new Winsor Newton purple alizarin madder for one of the structures, leaving the roofs white. The remote hill has become more yellow green, more opaque, and color dances in the middle ground where the crisper touches congregate, while the foreground remains a pale, thinly washed area. "The trouble is always in the sky and foreground; the middle ground falls right into place . . . Now I'm beginning to understand what I'm trying to do." His head turns less frequently and attention is more toward the

Barn After the Rain, *1969*
Pastel
13¾ x 16½"
Private collection, Cincinnati

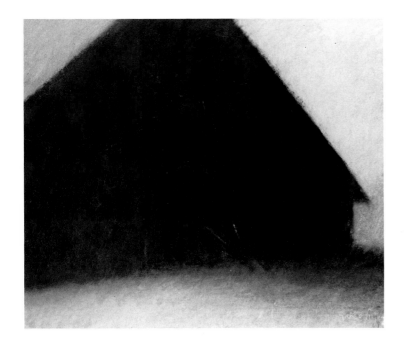

painting than toward the view. The hillside has green over an orange underpainting which occasionally turns into overpainting. "I don't have the density, but that you can add; it's transparency that's hard to add. Once a painting is dense then you can only get the transparency through color relations. I should densen up the foreground a little—the lavenders are really beautiful in that grass. I don't have a fixed system for color, it's purely intuitive."

"Why landscape? I have a need for space, for quiet. I don't include figures, although I'd love to find a way to have figures in my paintings. The problem is, what should they be doing there? Getting into a car? Contemplating? How to put them in so they don't serve as primary subject matter." Folding up the easel, he says, "I'm pleased when a start isn't too good because it gives me more to work on in the winter time."

After a break for lunch at the West Brattleboro Cafe, we returned to the morning's site. At first he wanted to face down the hill again, but then resolutely turned toward the northwest where the silver and yellow field sloped up to a fringe of trees silhouetted against the sky. "It's really nice being able to paint blue sky. I didn't know how to do it until about three years ago when I tried a manganese blue sky this time of year and it happened to be convincing. Since then I've been sensitized to blue."

After about a half hour of looking up the hill the 30″ x 52″ canvas is fairly covered, the near ground peach and pale greys, the upper field yellow and the row of trees dark with madder. It's a matter of finding color equivalents which also read as values. The velvety darks are blue, deep purple and bronze, and there are big splashes of yellow orange next to a sky made of manganese, ultramarine and cobalt. "I'm going from a cool blue near the sun to a denser, warmer blue over here. I'm getting wise enough to keep the whole thing underworked."

The paint is scrubbed on in loose strokes and the looseness and openness of the foreground really gives the sweep up the hill, where it ends in a pink rim against the trees. A deep green underlines the trees at the far right and there is a langorous downward line to the hill. "I wish I had another six inches of canvas on that side— it's so beautiful the way the trees really keep going. This painting seems to paint itself."

Driving back over small dirt roads we pause at various places he has painted, usually with barns, as well as to look for mushrooms and pick up windfalls. "Barns are fantastic structures; they look like stranded whales." Thinking of barns he recalled a statement he made for *A Sense of Place*:

"I believe that nostalgia in its best sense, i.e. a yearning after a Golden Age, informs most of the best landscape paintings . . . It's most clearly evident in Poussin and Lorrain, in Turner, . . . There are two generally discernable types of nostalgia—the one for antiquity, and the one for some kind of pastoral past. We in America don't

High Summer, *1972*
Oil on canvas
50 x 59"
Collection Sara Roby Foundation

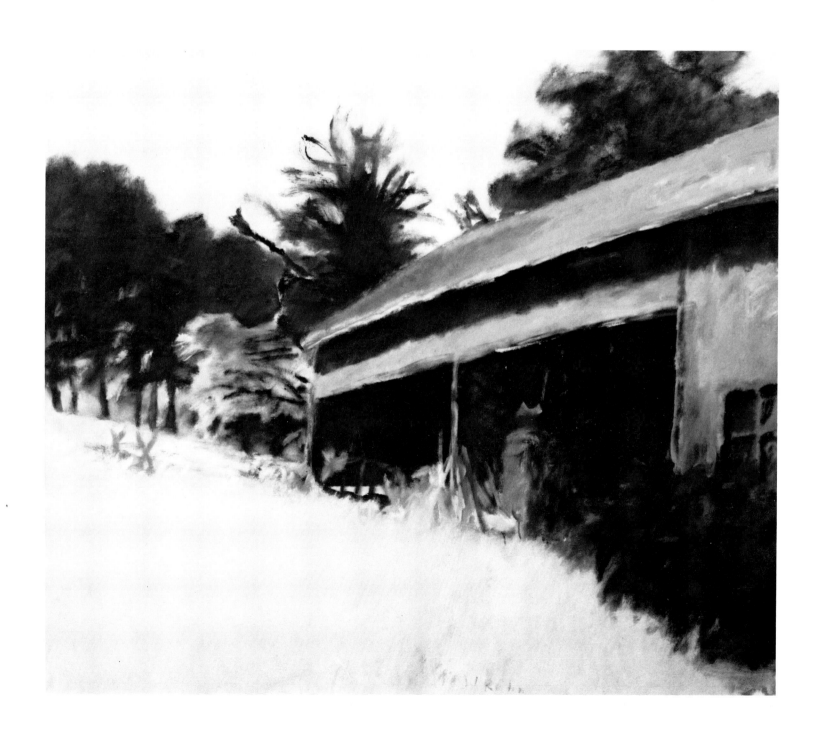

have any antiquity, so for us there is only 18th and 19th century rural nostalgia. It was then we had our heroic age, and a New England barn is to us as a Greek temple was to Poussin, the symbol of a whole tradition, laden with all kinds of good associations."[21]

Later that winter in the New York studio, the paintings started that fall day along with dozens of other starts are leaning against the walls in various stages of completion. Completion means tuning up the color, layering the paint for greater density and fluctuation of tone, and usually sharpening that one relation which is the key to the whole work. On the easel and adjacent walls are several versions of his corner view of the barn with the difficult lines of ramp, dormer, roof and foundation, resisting gravity on that steep slope. One version, painted for Emily, is tinted the palest pink, with exquisite violets and soft, jostling greens, jolted by a sharp blue window. "I like to paint these monsters because the shape is so strong that you can afford to be delicate. It's great to put your whole shoulder into a work and have it come out delicate. They're not easy paintings to do, these barns. The corner is hard, the dormer always has to be moved around, inside the door gives me trouble and the line above the foundation is always very difficult. By now I don't even know it's a barn any more. It's a problem, that's mostly what it is."

Another version of the barn corner has brash orange and violet streaked shadows next to the pinkish-grey and bluish barn siding. Again, there is a nearly bare lower right corner touched by strokes of orange, green and blue that are passages of pure painting, contributing nothing to clarify the image. He habitually avoids finishing off this corner, as if refusal to make the illusion complete implies that the view pulled down over the surface could lift right off it again. This barn series, combining lucid volume with translucent surface, is the most complete realization of Kahn's desire to make something "both solid and diaphanous." Possibly this imminent threat of vanishing relates to his early experiences and a lingering anxiety that what seems substantial may dissolve.

In the studio he begins to get restive when the paintings become, in his words, "too synthetic." "I'm not trying to deny these paintings, but I think that to make paintings that are wholly synthetic is deadly. This painting has such completely intellectualized impulses in it that I had to leave it; this part looks like nature; this part looks like my head."

He is discussing a horizontal canvas "Copse" traversed by a band of grey bare trees, above which hovers a wide streak of orange that insists on being just that, an orange stripe on a grey-violet ground, unable to justify itself in terms of the atmospheric space of the landscape. Although he welcomes working in the city, there comes a time which the abstract tendency becomes too strong and he feels the need to "get out and stir things up." At such times he goes off with his pastels for the day, or takes

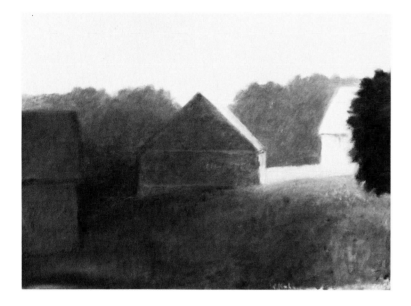

Adams Farm at Evening III, *1976*
Oil on canvas
52¾ x 73"
Collection of the artist

off for a week in Vermont to check on the color of snow patches in the late winter landscape, or to catch the first haze of buds on the apple trees in spring.

An example of a composition that verges on the synthetic is *Adams Farm in Evening,* 1976, of which there are three versions. In No. III, a red-violet barn in dead center is flanked by the flat shapes of two other buildings, equidistant from the central shape but resting on different planes. The problem he set up was to make these three flat shapes, without any perspective indicators, function in depth. Its a real Hofmann problem and the contrast of the delicately modulated green setting with the flat shapes of the buildings recalls Hofmann's juxtaposition of hard-edged planes and painterly areas, and his notion about the tension between push and pull in space. The static nature of the composition is countered by the opposition of the shadowy barn on the left, already engulfed in darkness, and the lingering light on the farmhouse on the right, as well as by the vibrating yellow where the trees are seen against the sky. A touch of alizarin at the lower right makes a plane of the foreground green, lifting it and signaling once again that the viewer is confronting a painting with its own internal order which is only incidentally a condensation of perceptual experience.

In contrast to the austere frontality of the Adams Farm series, the farm buildings of *Reed Place IV*, 1977 are clearly defined volumes fitting comfortably against the dominant diagonal of the field. The foliage in high-pitched orange resounds above the grey-violet of the distant hillside. The foreground plane is a pinkish field that stretches flat across the surface at the same time that it appears to slope down toward the house. A touch of turquoise-tinged green at the right sets off the delicate pinkish color fluctuations of the field, while the point of strongest contrasts—orange roof, purple madder shadow and flash of white siding—serves as a near-center pivot, its precise volume becoming a resting point around which the receding and advancing planes organize themselves. As a counterpoint to the massed oranges, the lacing of bare white and lavender branches suggest layers of depth against the rosy haze of the distance. At the lower edge the paint runs thin over visible raw canvas, as the artist again signals that we are dealing with an illusion, but then with masterful sleight of hand, he fools us anyway.

The alternation in Kahn's working rhythm provides for periods of stimulating input followed by a prolonged time for consolidation. During each summer's reconnoitering expeditions new paintings are fearlessly brushed in because there is no inhibiting pressure to see them through on the spot, (although this may occasionally and fortuitously occur). Later the problems they present can be worked out during lengthy sessions in the studio. When he goes out again he takes new knowledge with him, so that even familiar sites are seen differently and present new challenges.

The pastels, complete and often substantial works in themselves, also play a role in the foraging process. He is far readier to tackle the unfamiliar in the small format of a

Upper Pasture IV, *1979*
Oil on canvas
22 x 48"
Private collection, New York
(below)

Upper Pasture, *1977*
Pastel
11 x 14"
Collection Joan Sonnabend, Boston
(lower left)

Corral, *1977–9*
Oil on canvas
14 x 26"
Collection Melany Kahn
(lower right)

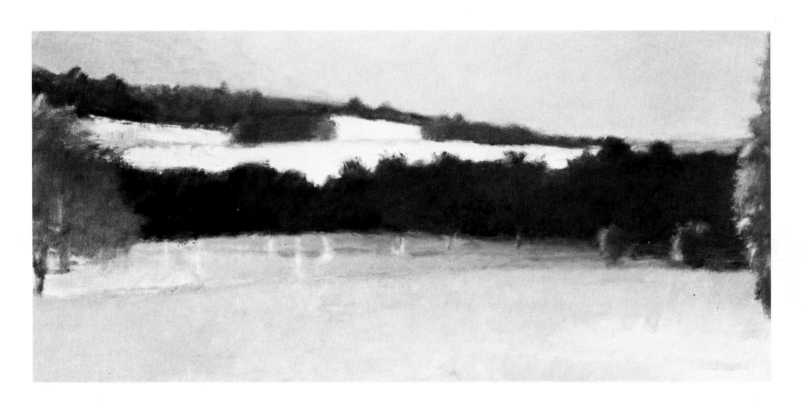

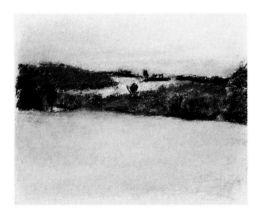

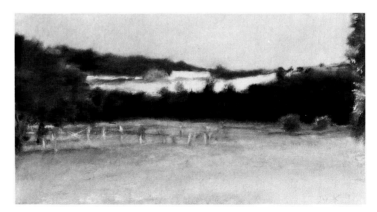

Upper Pasture III, *1979*
Oil on canvas
30 x 48"
Private collection, Houston

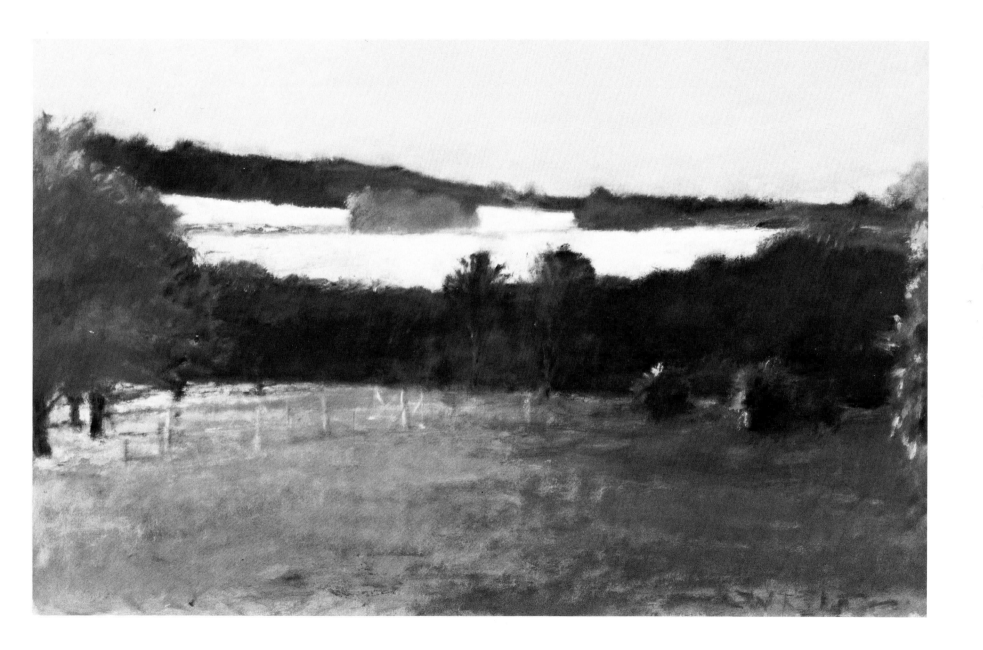

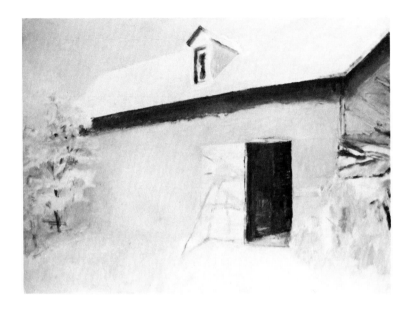

Barn Door and Dormer Window, *1978*
Oil on canvas
52¼ x 72"
Collection Museum of Art,
Rhode Island School of Design

work on paper than on canvas, so when he travels the pastels always accompany him. He may do several pastels a day on such a trip. He is less reticent about detail in the pastels because the medium is so delicate that he can be precise enough to indicate the make of a parked car and still not lose the sense that the scene is tenuously poised rather than firmly anchored. Visiting Key West in the spring of 1980 he quickly found new color relationships to convey the quality of tropical light in a series of pastel sketches, but he isn't prepared to work with the unfamiliar on a larger scale. In 1973 he returned to Venice for two weeks. Each day he made two pastels, going out to work early every morning and again in late afternoon. He delighted in the ease with which they were accomplished, in comparison with his agonizing struggles in the same place sixteen years earlier. In many cases the pastels also serve as take-off points for larger oils. Recently they have provided the basis for lithographs.

In 1980, a suite of lithographs, "Four New England Views in five Colors," which look remarkably close to the original pastels, were printed at Solo Press under the supervision of master printer Judith Solodkin. To watch Kahn work with the technicians in the print studio was a revealing experience in terms of his thinking about color. The lithograph they were working on was *Windsor Barns*, which had already been printed in orange, yellow, violet and gray. The problem at hand that day was to decide on the fifth color. Kahn requested a blue "to give some transparency." The technician mixed a cobalt with a considerable amount of white, inked the aluminum plate and the proof was pulled. The artist decided that it should be a deeper richer blue so more blue was added and another proof made, which showed a considerable enlivening of all the tones. He squinted at the two versions tacked up next to the earlier four color-proof.

"I always like it best at four colors, but it's a little incomplete. By the time I'm a good color printer, I'll learn to add without taking anything away. This is like three-D chess, there are so many variables." Pointing at the blue overprinting in the most recent proof, he continued, "What I like is something in here; this print with the darker blue has a tremendously tuned up vibrancy. It creates a whole different vibrancy on the barn roof." When a Thalo blue with less white was tried, it came through with more intensity and he said: "I haven't got anything in reserve to reintegrate that —it's too blotchy." He took the proofs along with him to work over with pastels in the studio.

Weeks later when the lithograph of the *Windsor Barns* was completed, there was no blue at all. The fifth color was light greenish-grey, which appeared to maximize the power of the red and orange areas, whereas the saturated blue had competed with them. The final print was a demonstration of his theories on tonality, that is, his belief in the effectiveness of balancing tones of lower value against hues at full intensity.

Although Kahn has often preferred in the past a planar and frontal landscape composition, he has chosen more recently the seemingly random sideways glance,

that makes a view seem incidental, as if glimpsed in passing. *River Bend I*, 1978, is such a painting with its patch of river surface seen through an angled row of trees like the late Corot, *Bridges at Nantes*. Boldly the artist has tackled a difficult vantage point with a road, a sand-covered sloping bank, the procession of bare trees, the river with its reflections and the further shore all converging toward a central vanishing point, masked by the trees. Although each of these elements in the actual landscape is at a different eye level, he has contrived to make them plausibly contiguous in a space that exerts a strong pull into depth. Simultaneously the attention is engaged by the crisp dry brush-drawing of the scraggly tree branches and the feathery washes of rose and blue violet tinting the foreground patch of sand. While the color is predominantly blue and blue-black, he has managed to introduce small glows of warming yellow without having them seem arbitrary.

Back of the House, 1980, poses even more complex spatial problems. The hub of conflicting directions is the angle formed by two wings of a barn-red building which pull toward opposite sides of the canvas. Something about this canvas tugs at the memory and *Arnold's Place* of more than 25 years earlier comes to mind. Under the layers of searingly bright pigment is that same difficult angle of an L shaped building with competing directional pulls masked by the foreground tree and arbor. The new work, recalling the earlier composition, suggests that one predilection in his work is for potential conflict using a hub of opposing directional lines as the pivot of a composition. It is similar to the problem he posed in the *Corner of the Barn* series, in inverse perspective. In *Arnold's Place* a welter of vehement brushstrokes as well as discordant color accompany the disquieting perspectives. Although the paint is thinly applied in the new work and the brushwork exquisitely deft, there is still an echo of the old Expressionist canvas in the impulsive brushing he has been able to maintain, and in the powerful stridency of the red against the purple.

Not all the current paintings manifest such a heightening of tensions. There are canvases with dominant horizontals, such as *Moore's Field*, 1980 that are serene both in color and composition. In the latter painting the pond reflecting the sky is like an eye in the earth and it has a harmonious completeness and stability. Knowing how to achieve harmony, he can stretch toward disharmony in some of his works, confident that he can keep them from falling apart altogether.

When Kahn speaks of "doing Rothko over from Nature," he must have in mind the hovering effect which keeps Rothko's color areas from affixing themselves to a surface, a quality he has often emulated. He may be referring also to the color interactions which furnish the basic impact in Rothko's mature work, for in one sense he himself is close to being a color field painter, using the sensuous appeal of a hue at full saturation and the vibrations of juxtaposed colors to carry the emotional weight of his painting. He has learned how one color will lift away from another, how others will merge with a shimmering effect, how scintillating an expanse of color can be when brushed over layers of varigated tones, and how to keep all the color

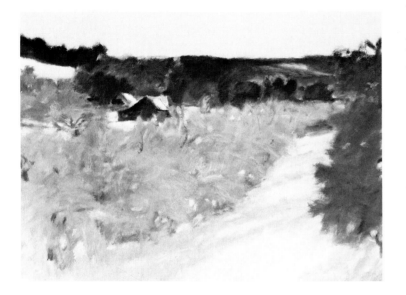

Midsummer Orchard, *1979*
Oil on canvas
28 x 38"
Private collection, Houston

dynamics of a painting working toward an overall radiance. He shies away from color systems, taking a pragmatic approach, letting what happens with the colors take him by surprise or experimenting with devices to tune them higher. When questioned about a mauve-grey sky in a new painting, he said, "I put a fake sky in; what I really wanted to do was establish a relationship between this yellow and this pink and I couldn't do it with a blue sky." Sometimes the arrival of a new tube of paint will lead him to see that hue in nature; Winsor-Newton's new Purple Alizarin Madder led him to seeing in terms of deep darks and sharp lights, so he painted a barn with a flat white roof against a side of black purple.

The one essential principle that he does insist on in deploying his colors is the use of values as well as hues. He cites the example of Corot who "used greys and muted greens so that when he uses a green of full intensity it really counts" and Matisse who was the "only one among the Fauves who used values as well as fully saturated colors." This is why he can get away with his high pitched chromaticism; the shrill colors sound against muted tones and they are stronger because the contrast in values brings out the intensity. Yet it's not quite the same as an abstract color symphony a la Delaunay or even a Fauve composition in a major key, because Kahn has succeeded in giving his vibrant colors credibility as equivalents to a system of perceived relationships in nature.

When he goes outside to paint, he may carry a box with as many as sixty colors. A glance at the pigments that were on his palette in the studio one morning gives an idea of the range he works with:

> Naples yellow—Grumbacher
> Barium yellow—Block x
> Naples yellow reddish—Rembrandt
> Cadmium yellow deep—Winsor-Newton
> Cobalt violet deep, also light—as many as 4 different makes
> Tertiary permasol red—Shiva
> Warm grey—Lucas
> Blue black—Winsor-Newton
> Capucine yellow light—Block x
> Shiva yellow citron—Shiva
> Terre verte—Weber
> Jaune Indien—Lefevre
> Ultramarine blue—Rembrandt
> Cobalt blue—Block x
> Green gold—Shiva
> Capucine yellow dark—Block x

Nothing is mixed on the palette, only on the canvas. When the surface gets too dry, he adds linseed oil or even a spray of retouch varnish.

Black Shadows of Summer, *1978*
Oil on canvas
40 x 52"
Collection Springfield Museum of Fine Art

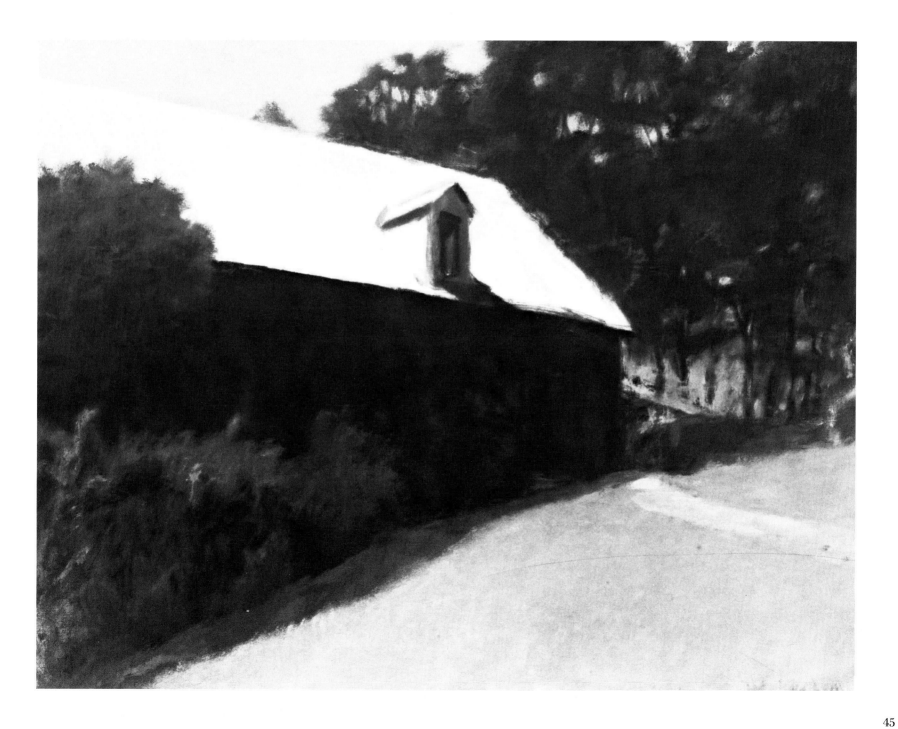

Recently Kahn has tended to choose rather neutral and anonymous subject matter, such as sand pits, a brush heap and even subjects verging on genre like country fairs and horseshows, those last in pastels. He is not averse to including autos, trailers and tractors as incidental parts of his landscapes. One of the newest canvases even includes figures: the subject is the shed attached to his house as it undergoes reshingling and, in explanation of the raw color of the roof, he includes the workmen. He has never been one to seek out the grand and dramatic in landscape, but his recent inclination is increasingly toward the offhand and the quotidian, a subject matter compatible with his own temperament.

"I think there is something healthy about these paintings. I can get by with small claims here. What I hate about the cultural life of the moment is the terrible self-consciousness and pomposity. I don't want to be a hero. I just work here."

At age fifty-three, Kahn has reached a relaxed and confident stride in his painting. He has an air of anticipation about his own work and it clearly absorbs him fully.

"I feel sexy about painting. I want it to be juicy and I want it to be strong. I'd rather be standing here at my easel, not doing anything else. I'm happiest when I go up to Vermont, alone for a week to paint."

Asked whether events in the world at large have an effect on his work, he reflects: "Who can relate ideology to art at this moment? I can rationalize it, but I don't think I'll come up with anything very significant or original. I really don't have any illusions about making things in general better than they are. I just want to make my paintings better."

Unlike some contemporaries who have been trapped into belonging to a single decade—or less—Wolf Kahn's art belongs to the modern tradition as it continues to unfold. Surveying his work at mid-career, it is possible to discern some of the strands that have been woven into the fabric of his art and to perceive the various phases of growth and consolidation into which his paintings may be grouped. They arrange themselves almost by decade, following a thesis/antithesis/synthesis sequence, starting with the Expressionist canvases of the early fifties. During that phase there was a gradual stabilizing of composition, calming of color and ordering of the once frenetic brushstrokes. Then in 1958 came the major change from chromatic to tonal painting and from figure to landscape, marking the beginning of a period of increasingly dark and heavily painted canvases that at times resembled scarred battlegrounds. At the end of a decade, in 1968, as he shifted locale from the seacoast to Vermont, color re-emerged, this time in large, shimmering expanses, and assumed the dominant role. The passion that was manifest in the seething paint and convoluted forms of the early work is now largely invested in color. Vivid as the sense of place may be, as one glimpses the rim of violet hills beyond a yellow pasture, it is ultimately color that summons a surge of emotion before these

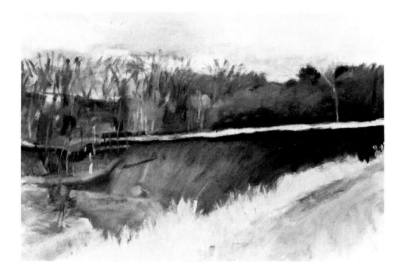

Gravel Pit, *1980*
Oil on canvas
24 x 36"
Collection Mun Galería de Arte, Madrid

canvases. Otherwise the paintings are calm; the scale of the landscapes is comfortable, without overpowering heights and anxiety-producing distances, and there are barns, clearings, roads and fences to forestall the menace of emptiness.

The sources that have nourished his art include, on a biographical level, an artistic family background, the positive reinforcement which his early diligence in drawing received, the idealistic attitudes about art generated at the Hofmann School, the encouraging support system that the Hansa artists furnished for each other, and his early uprooting with its residue of anxiety that threatens to turn the landscape into a mirage. In terms of artistic formation, inevitably the major force is that of Abstract Expressionism and the attitudes and stylistic traits that clustered around it, particularly its affirmation of the artist as an active self. As an adjunct to the above, there is the specific inspiration of Rothko, as well as some ideas drawn from subsequent color field painting. Above all there is the ghost of Hofmann urging him on to the struggle. Although there are artists among his contemporaries whose work he admires, even acquires, Kahn is not concerned about the position of his work in the welter of contemporary styles, rather he cares about "being part of the last five hundred years."

His position today might be considered not unlike that of Corot in his time, who avoided the excesses of the prevailing Romanticism of his earlier years and was little tempted by the succeeding Realist and Impressionist movements, as he continued to produce modest, workmanlike paintings of exquisite harmony. As Corot set for himself problems in volume, atmosphere and tonal relationships, he was also taking quiet cognizance of the changes in modes of perception being registered around him and he subtly incorporated them in his work. He sought a synthesis of solid form and diaphanous light, passing through phases that emphasized first one, then the other, until they were integrated in his late works.

In similar fashion Kahn has worked toward synthesis, bringing together in his work many elements from the complex art of his day, but he has managed always to keep that synthesis precarious, to leave open questions that demand to be taken up in the next work. Out of wisdom or necessity he has, to borrow Henry James words, "kept part of his talent invested in unsolved difficulties." Yet he is able to achieve the lyrical even while he tackles the idea. His landscapes evoke the remembered sensation of season, place or time because he has found the color equivalents for those sensations. The gasp of autumnal orange against a cobalt blue, the blanching noonday light, the radiance of a sunlit field make one feel, more than see, what was experienced at that time and that place.

In strangely unscientific words, Alfred North Whitehead wrote: "A color is eternal. It haunts time like a shadow." Coming back again and again to one of Kahn's shimmering landscapes, feeling it live through the palpitating light that pulses in tune with larger energies, one understands the sense behind Whitehead's words.

Autumn River, *1979*
Oil on canvas
52 x 72"
Collection Metropolitan Museum of Art, New York
Gift of Martin Ackerman Foundation

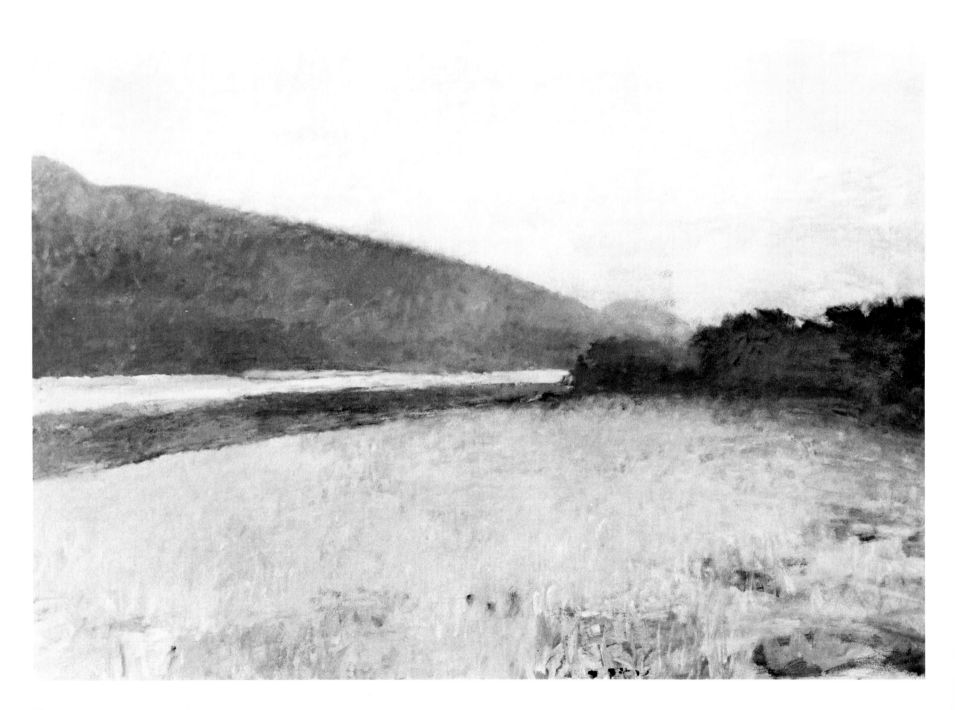

Notes

1. Harold Rosenberg, "Hans Hofmann, the life class, *The Anxious Object*, New York, 1966, p. 134.

2. *Op. Cit.*, p. 148.

3. Wolf Kahn, talk given at the College Art Association, New York, January, 1973.

4. *Ibid.*

5. "Subject, What, how or who?," *Art News*, April, 1965, p. 61.

6. *Ibid.*

7. Nov. 3, 1953.

8. Nov. 1953.

9. *Arts Digest*, Nov., 1953.

10. *Art News*, Feb., 1955.

11. *Arts Digest*, Feb. 1955.

12. p. 71.

13. Dec. 4, 1955.

14. Published by E. H. and A. C. Friedrichs Co., Artist's Materials, Vol. 3, No. 2, February, 1955.

15. *Folder*, Tiber Press, 1459 Third Avenue, 1955, No. 3.

16. *Time*, March, 1957.

17. *Ibid.*

18. "New Look, Abstract Impressionism," *Art News*, March, 1956, p. 36.

19. Wolf Kahn, talk at the New York Studio School, 1979.

20. Alan Gussow, *A Sense of Place, the Artist and the American Land*, p. 122.

21. *Ibid.*

Installation view of the 1979 Wolf Kahn exhibition at the Borgenicht Gallery, NYC.

Arnold's Place, *1954*
Oil on canvas
28 x 36"
Collection of the artist

Self Portrait, *1954*
Oil on canvas
44 x 60"
Collection of the artist

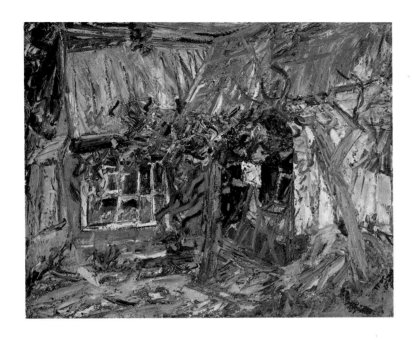

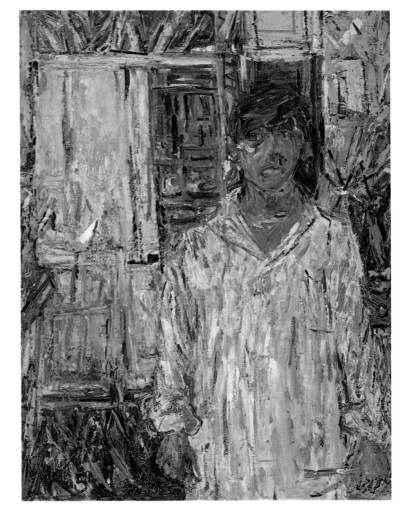

Portrait of Frank O'Hara, *1953–4*
Oil on canvas
42 x 40"
Collection of the artist

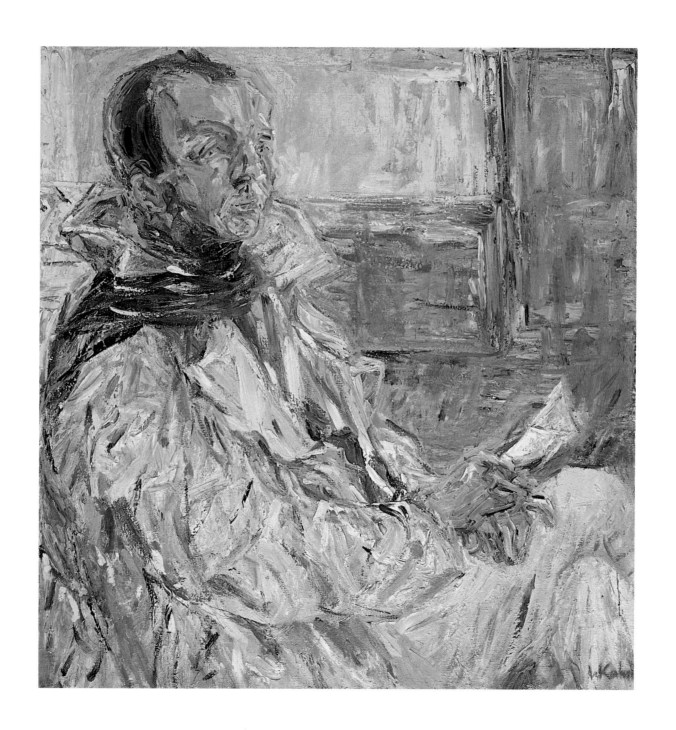

Large Olive Grove, *1957–8*
Oil on canvas
47½ x 54¾"
Collection Whitney Museum of American Art
Gift of the Friends of the Whitney

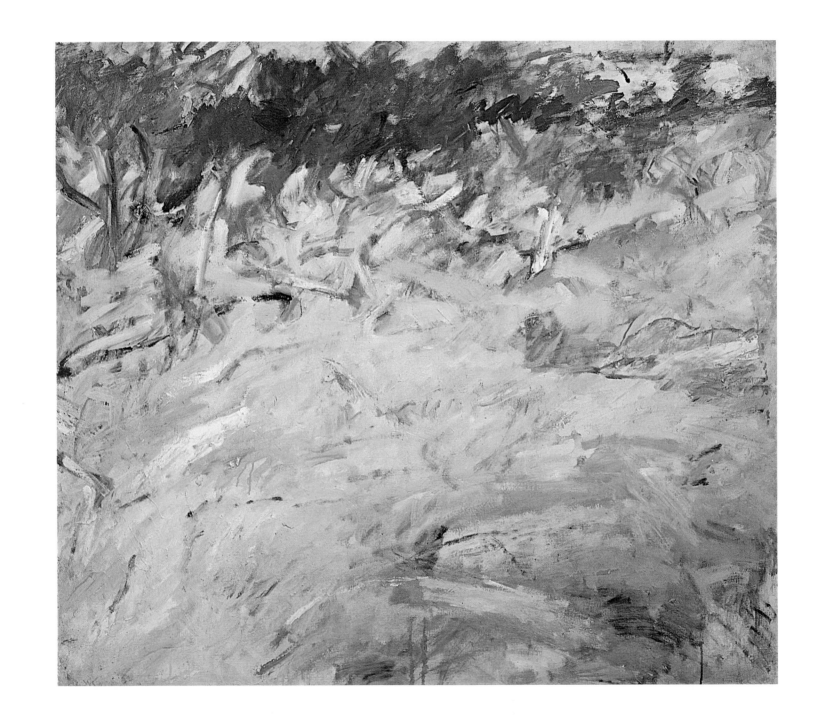

View Across the Plain, *1958*
Oil on canvas
60 x 72"
Collection of the artist

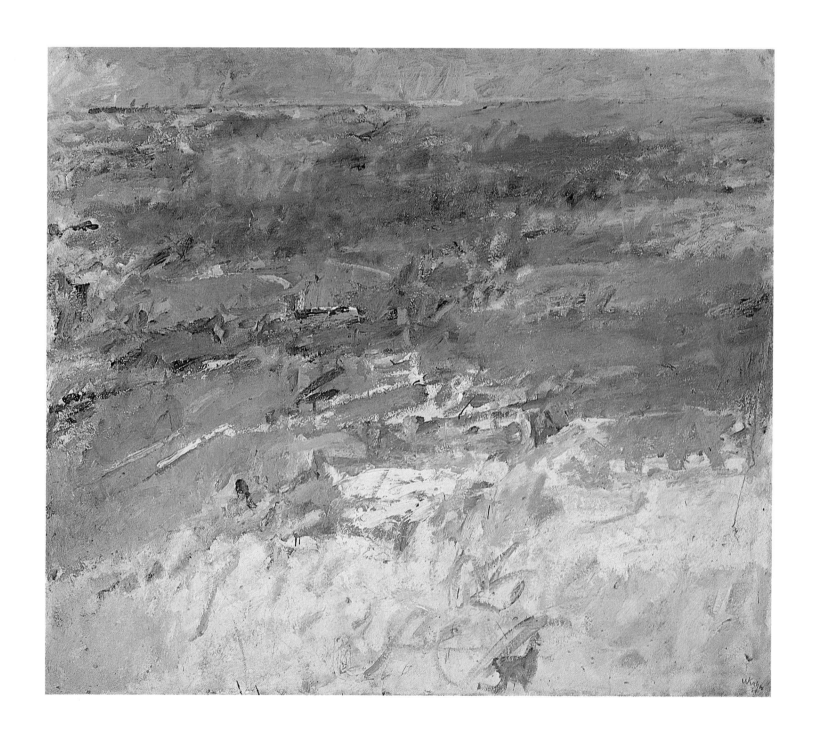

Tree Curtain, *1966*
Oil on canvas
16 x 20"
Collection of the artist

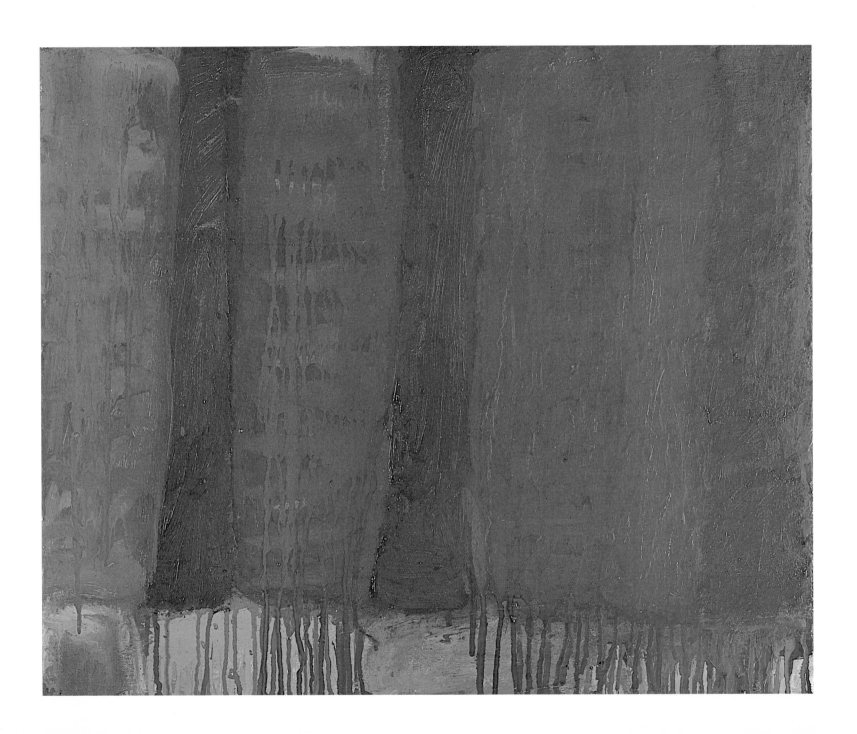

Edge of the Woods, *1964*
Oil on canvas
37½ x 39"
Collection of the artist

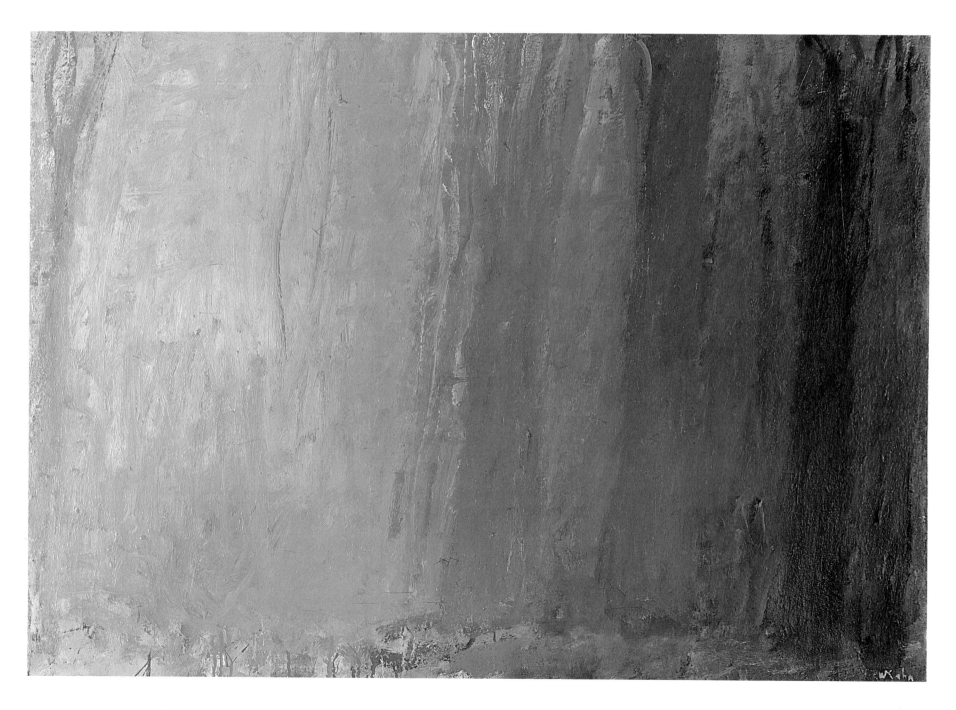

Power Line I, *1970–71*
Oil on canvas
40 x 50"
Present whereabouts unknown

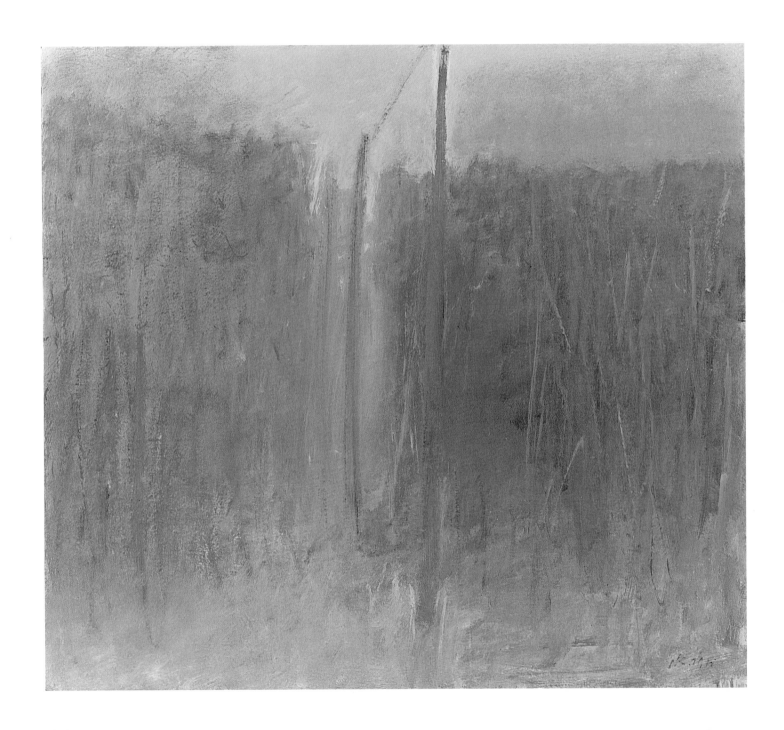

First Barn Painting, *1966*
Oil on canvas
43 x 50"
Collection of the artist

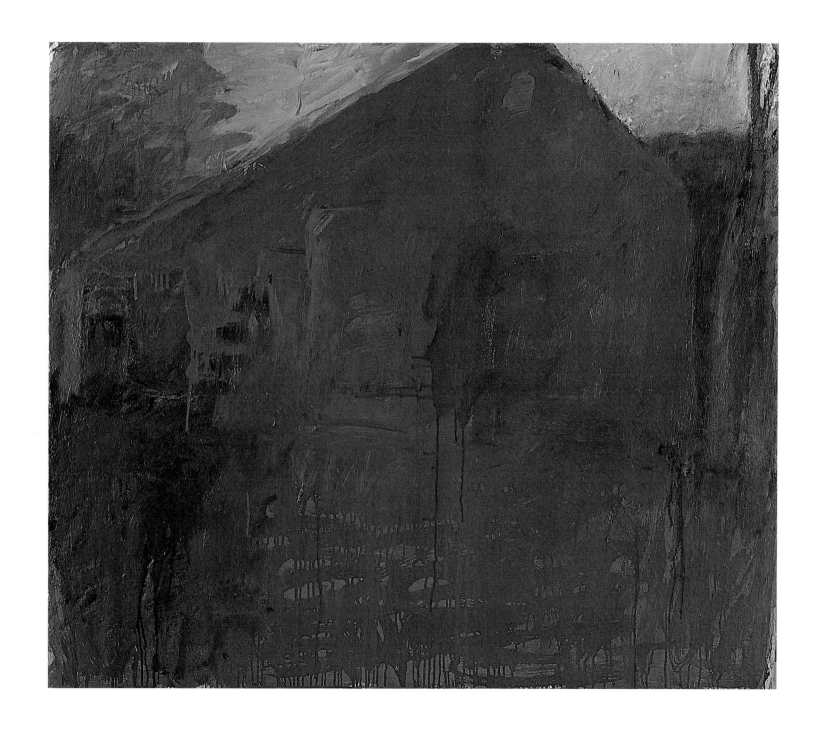

Yellow House, Maine, *1968*
Oil on canvas
50 x 40"
Collection of the artist

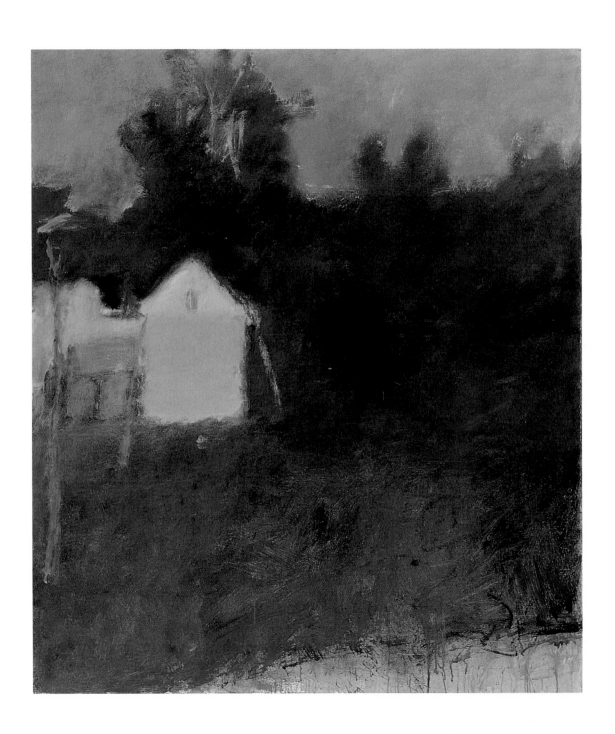

Summer Home, *1971–2*
Oil on canvas
40¼ x 66¼"
Collection Mr. & Mrs. William Goldman, N.Y.C.

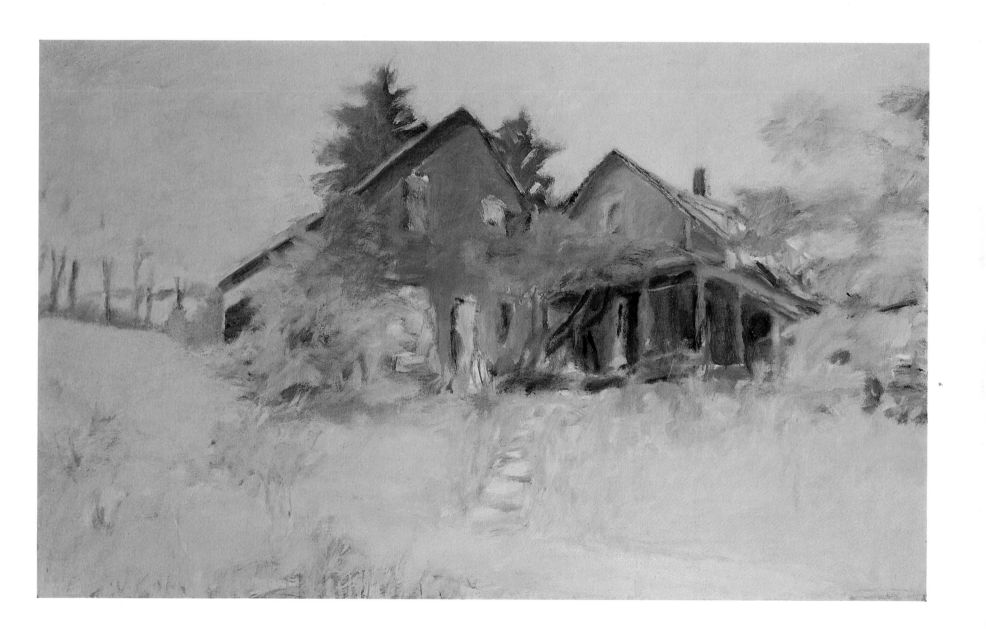

Yellow Field II, *1973*
Oil on canvas
30 x 38"
Private collection, Washington, D.C.

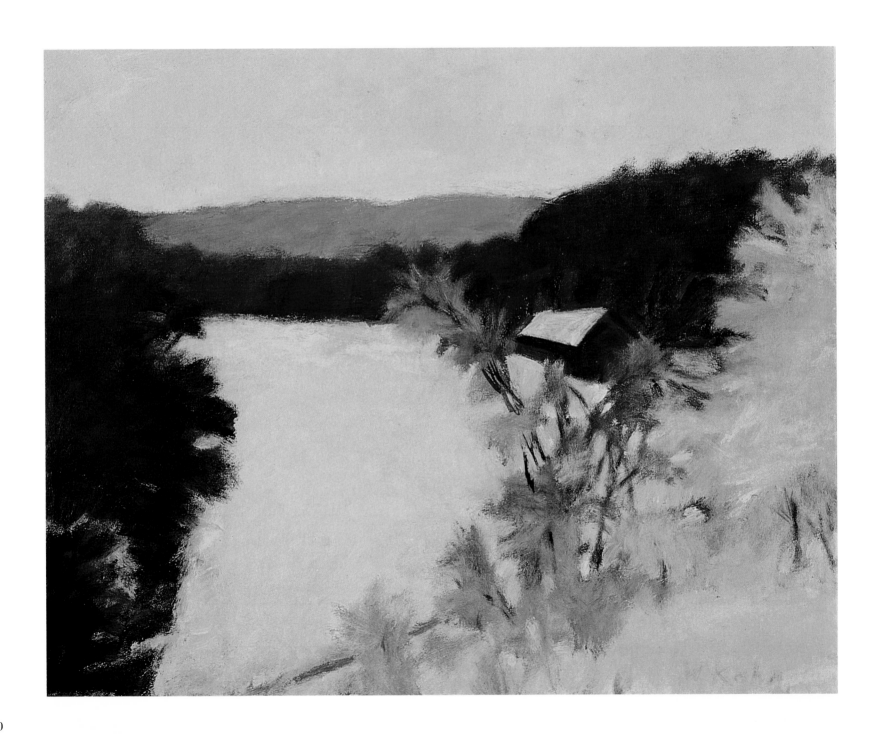

Adams Barns, *1973–4*
Oil on canvas
52 x 52″
Collection Loretta & Robert K. Lifton, N.Y.C.

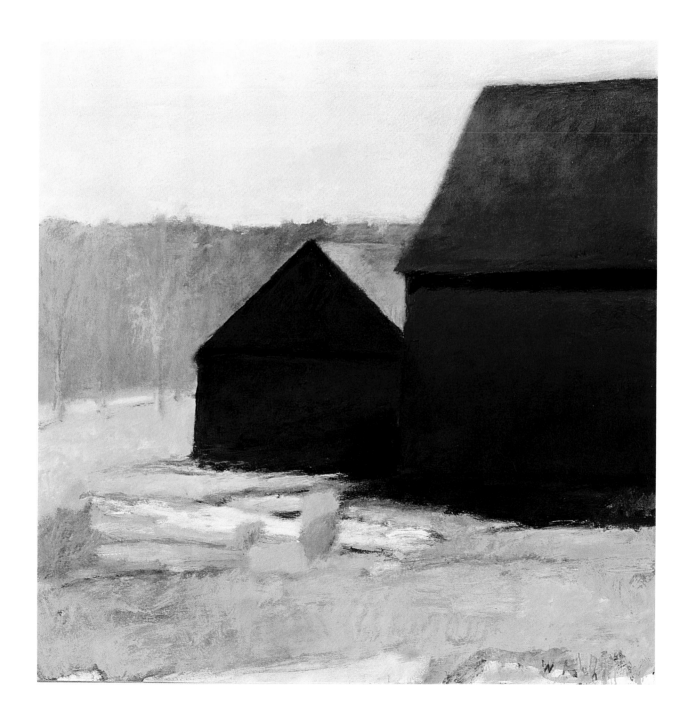

Pond and Pinewoods, *1973*
Oil on canvas
36 x 50"
Private collection, N.Y.C.

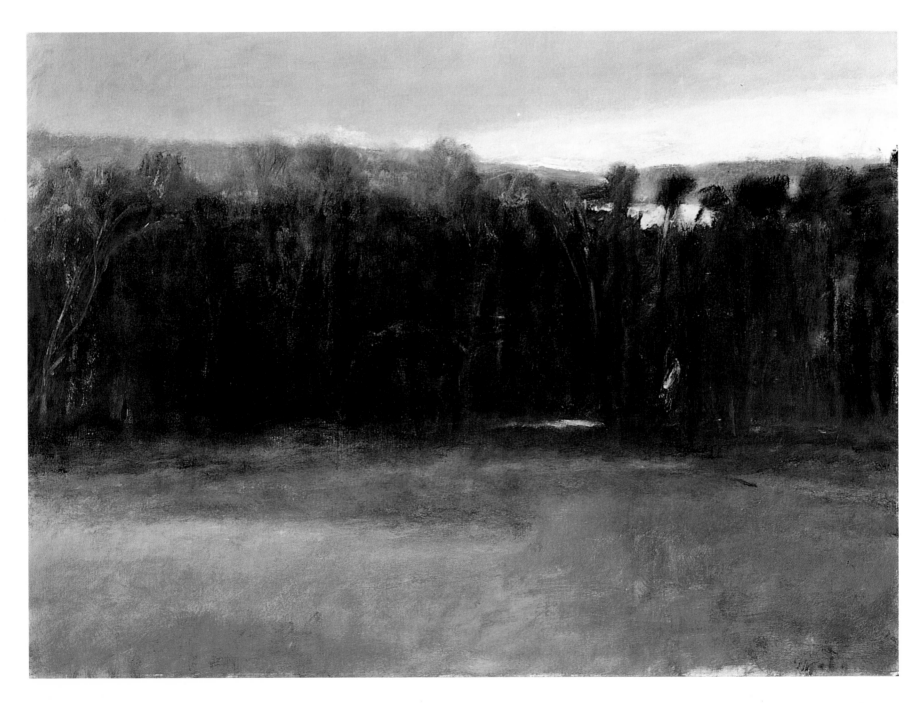

Adams Barns at Dusk, *1975*
Oil on canvas
44 x 66"
Collection Grace Borgenicht Gallery N.Y.C.

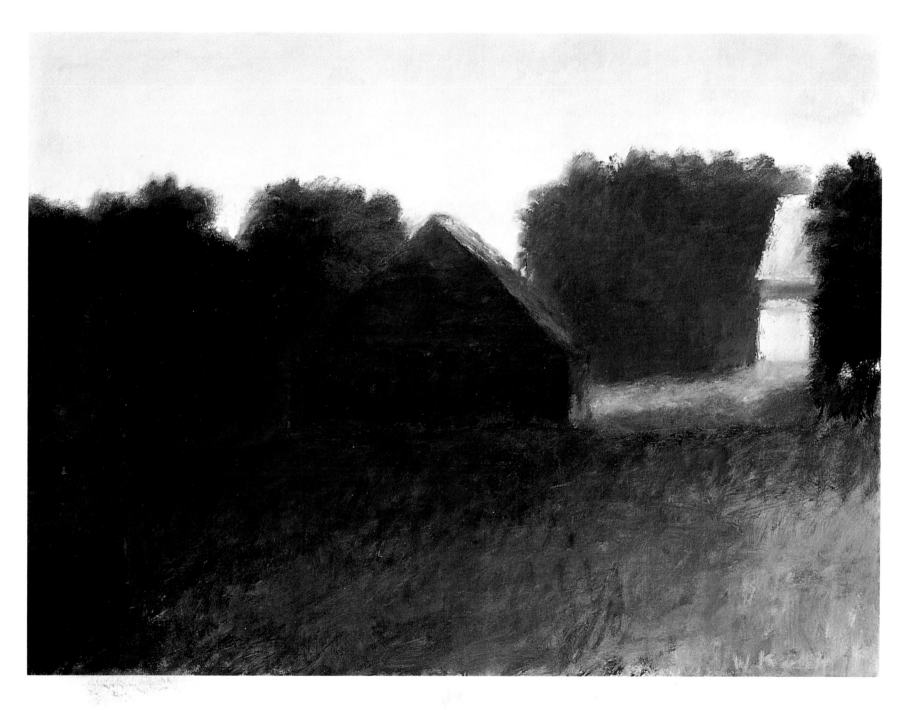

Tracks Along the Connecticut, *1979*
Oil on canvas
50 x 66"
Private collection, N.Y.C.

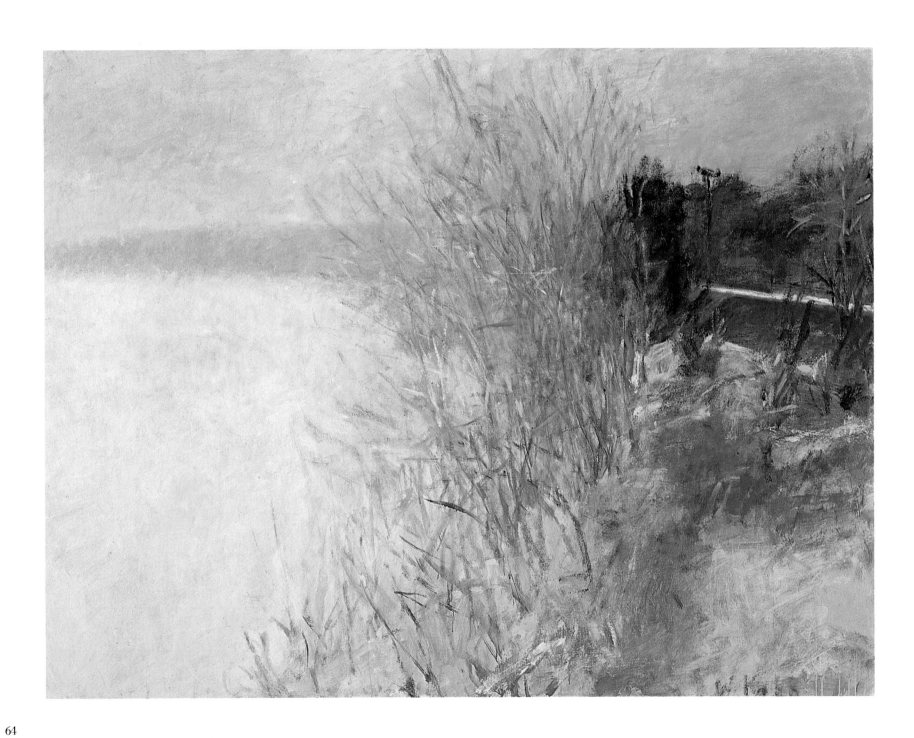

River Bend I, *1978*
Oil on canvas
38 x 41"
Collection Dr. & Mrs. Harold B. Ehrlich, N.Y.C.

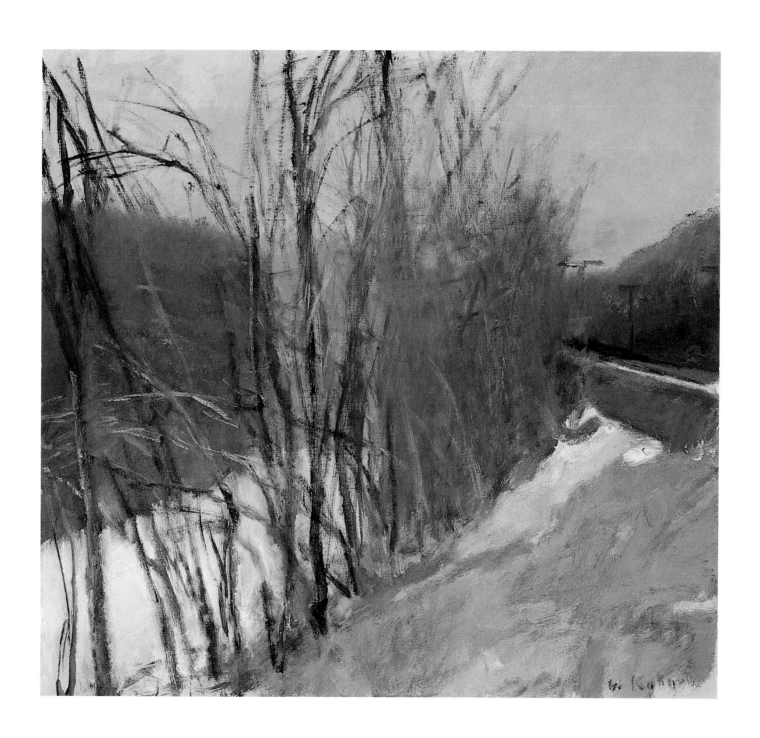

The Big Black Barn, *1977–8*
Oil on canvas
52 x 72"
Collection Pennsylvania State University
Museum of Art

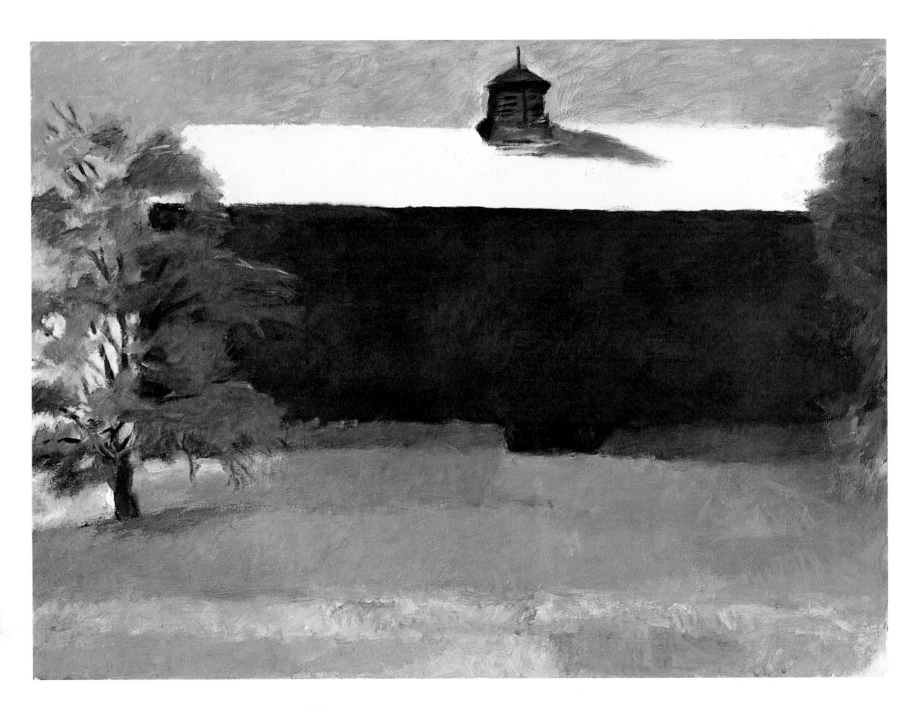

Barn, *1980*
Pastel
22 x 30"
Collection Continental Grain Co.

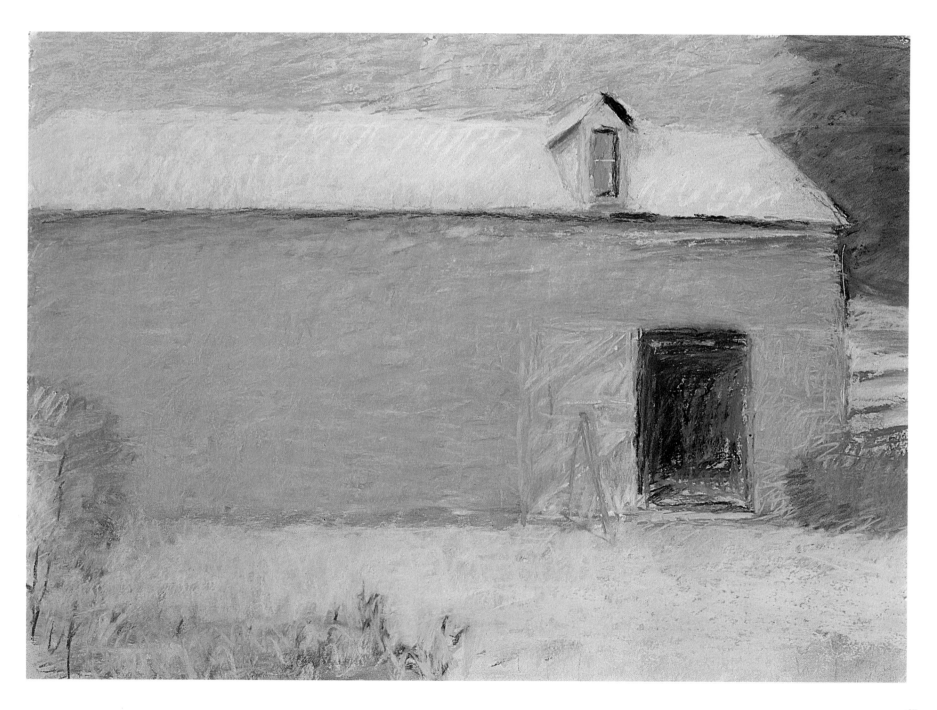

Morning Haze, *1978–9*
Oil on canvas
50 x 54"
Collection L. A. County Museum
Gift of Mr. & Mrs. Morley Benjamin

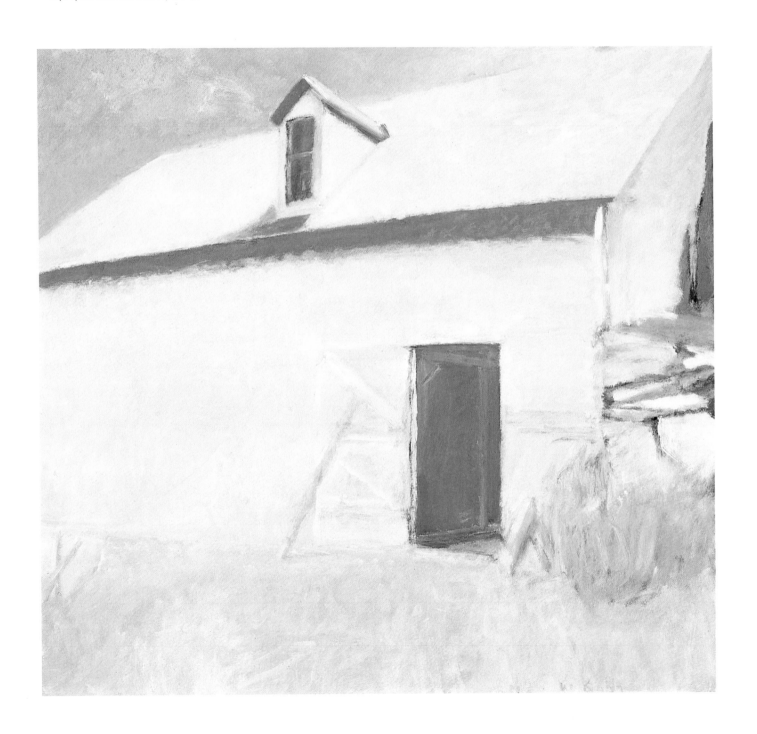

Barn in May, *1980*
Oil on canvas
44 x 52"
Collection Emily Mason

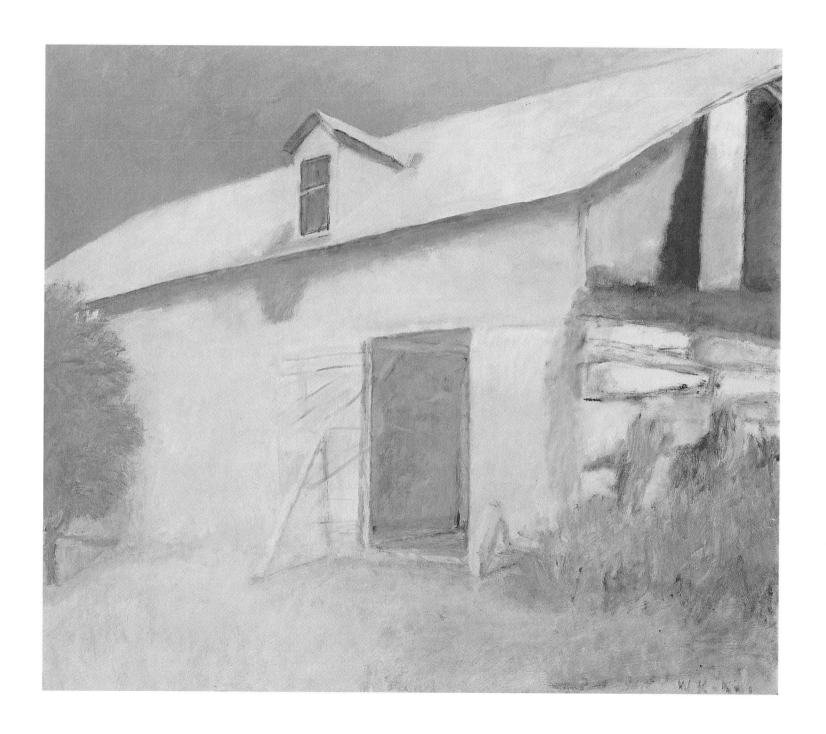

Barn, Shed and New Hampshire Hill, *1974*
Oil on canvas
44¼ x 67¼"
Private collection, N.Y.C.

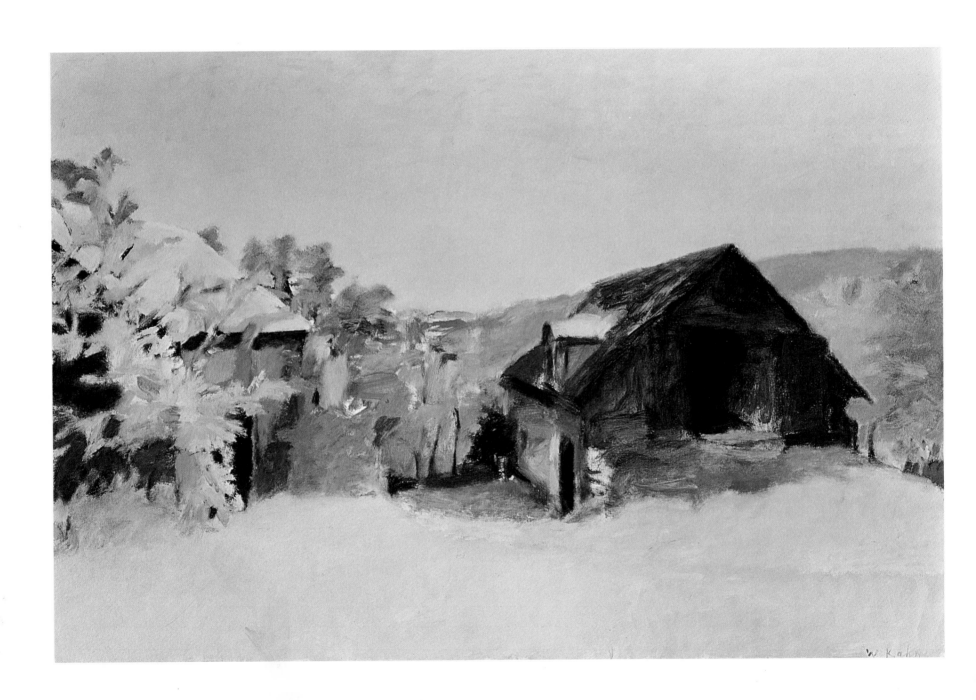

The Reed Place IV, *1977*
Oil on canvas
36 x 52"
Private collection, New York

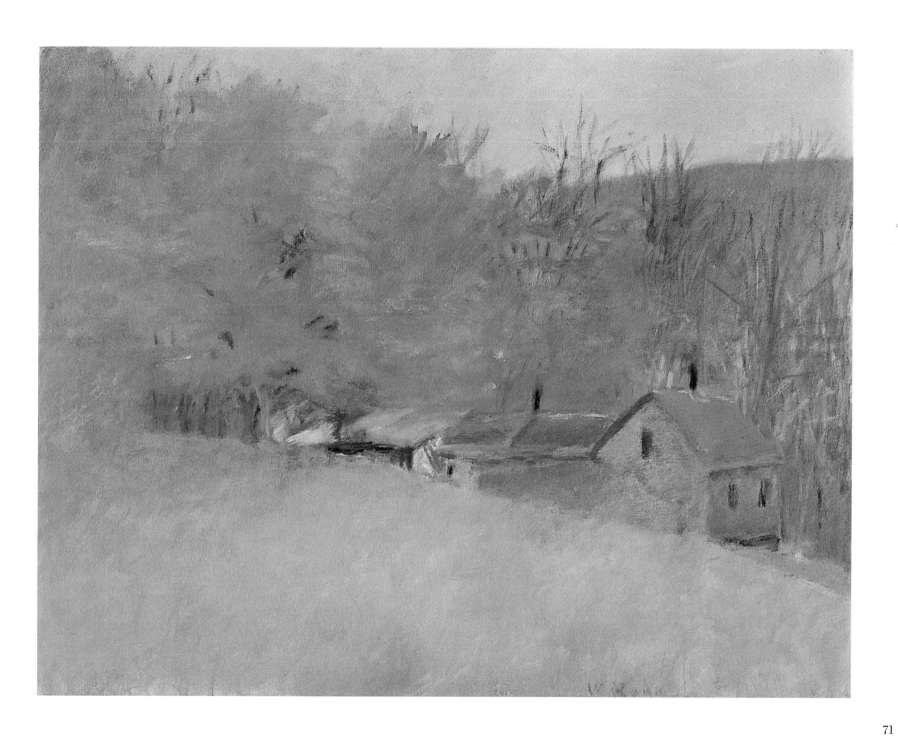

Afterglow, *1974*
Oil on canvas
40 x 66"
Collection Whitney Museum of American Art
Gift of Harry & Margery Kahn

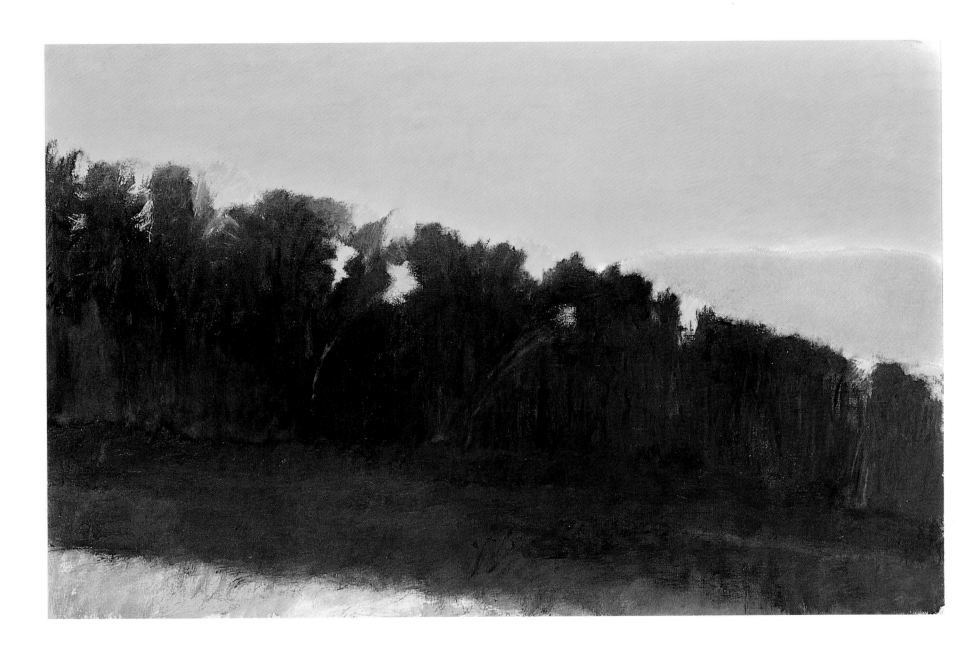

Copse, *1980*
Oil on canvas
52 x 72"
Collection of the artist

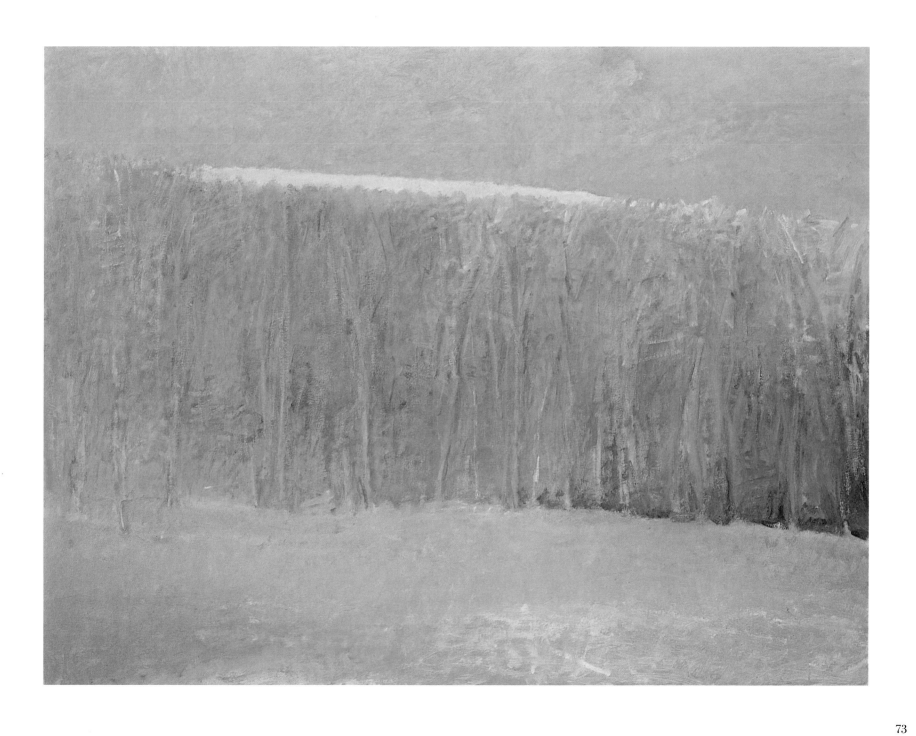

Barn Head-on, *1979–80*
Oil on canvas
53 x 60"
Collection of the artist

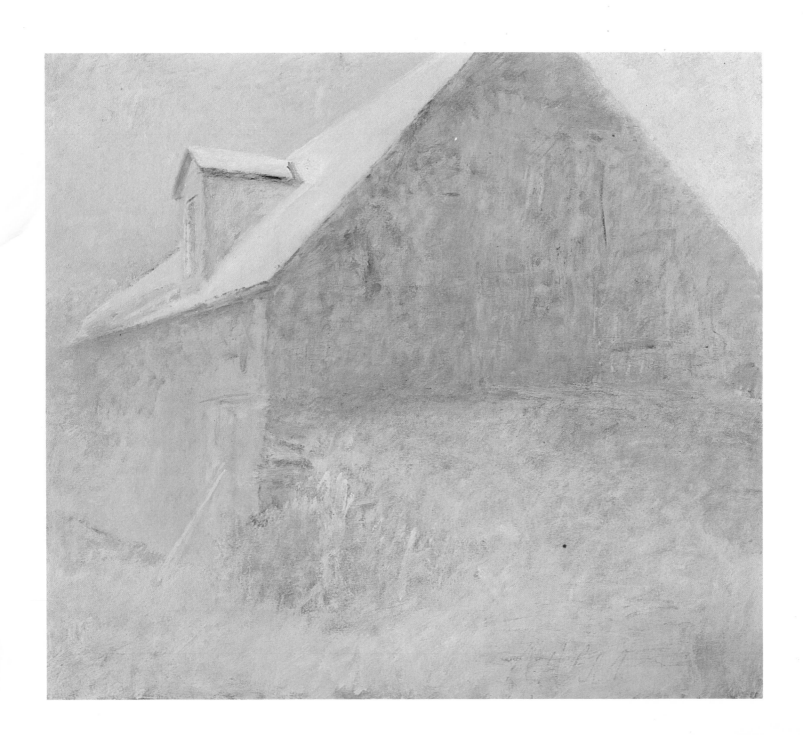

Off the River Road, *1978–9*
Oil on canvas
52 x 72"
Private collection, N.Y.C.

Off the River Road, *1979–80*
Pastel
17 x 22"
Collection Meredith and Cornelia Long, Houston

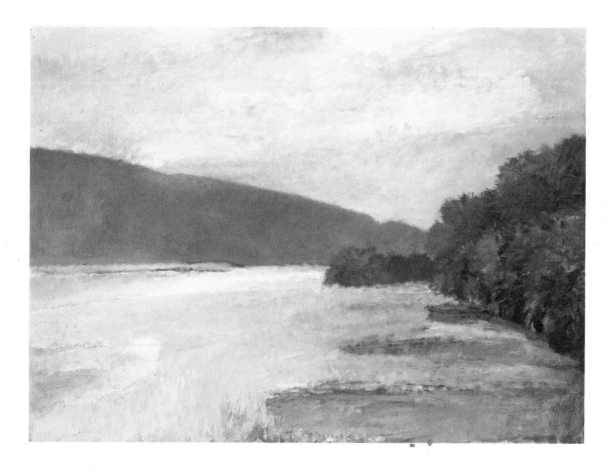

Summer Haze, *1980*
Oil on canvas
52 x 72"
Collection Meredith Long Gallery, Houston

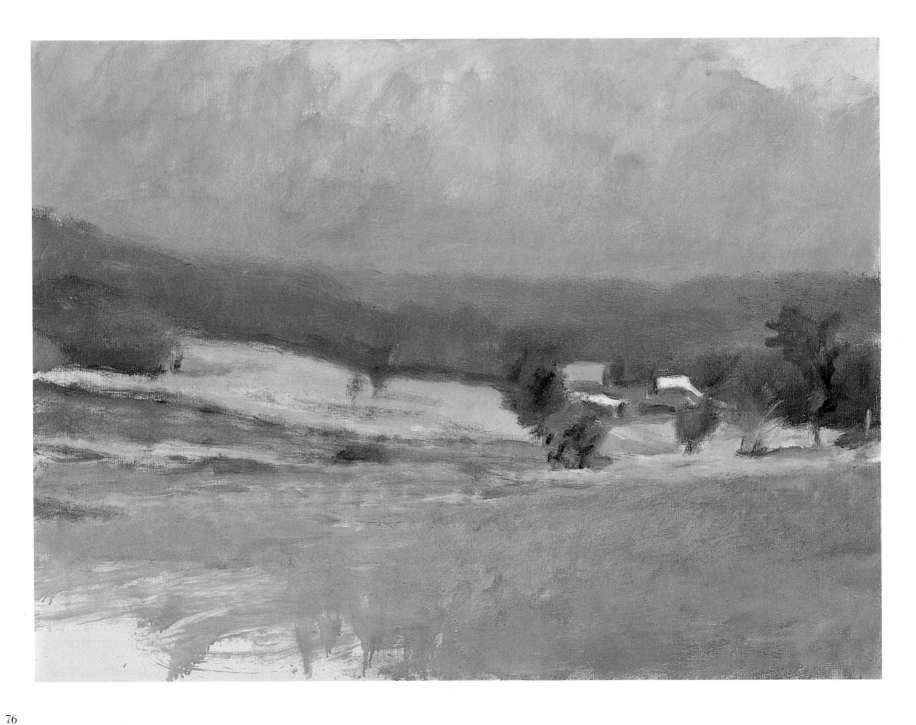

Bad Weather Approaching, *1980*
Oil on canvas
28 x 38"
Collection Grace Borgenicht Gallery N.Y.C.

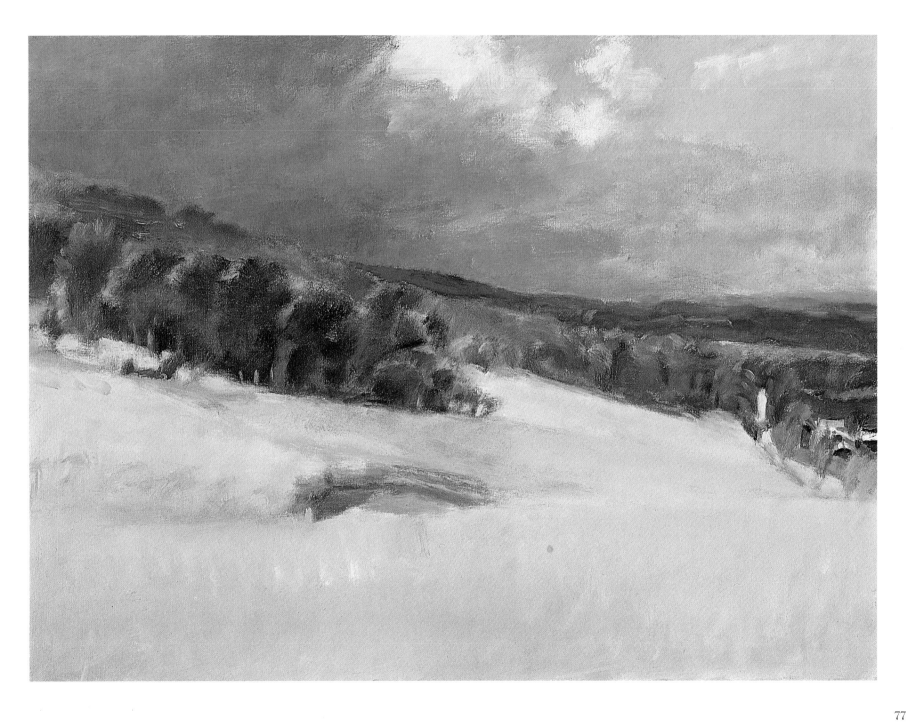

The Connecticut River at Dusk, *1977*
Oil on canvas
44 x 72"
Collection Rahr-West Museum, Manitowoc, Wis.

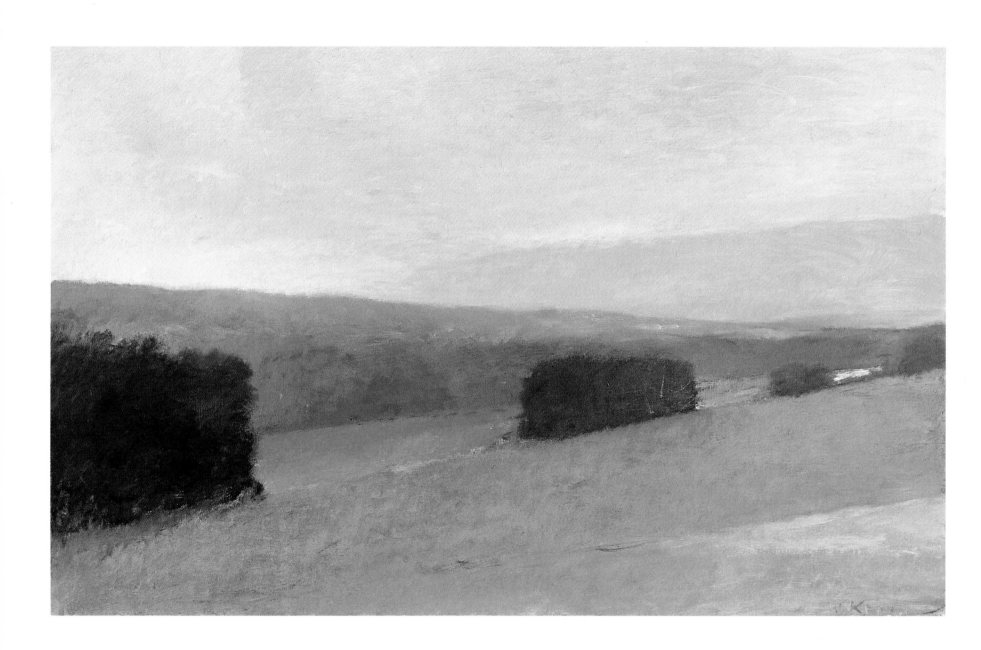

The Connecticut Valley at Vernon I, *1979*
Oil on canvas
24 x 52"
Collection Emily Mason, N.Y.C.

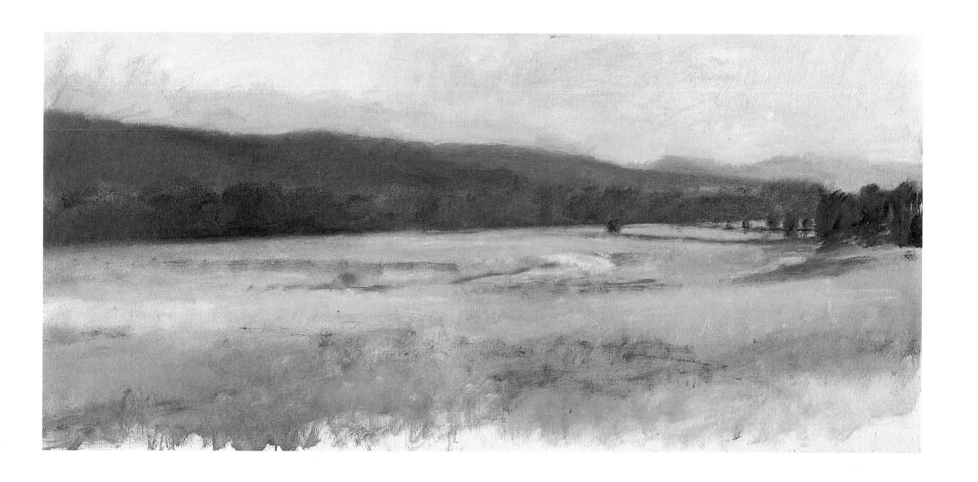

Gravel Pit I, *1980*
Oil on canvas
36 x 48"
Collection of the artist

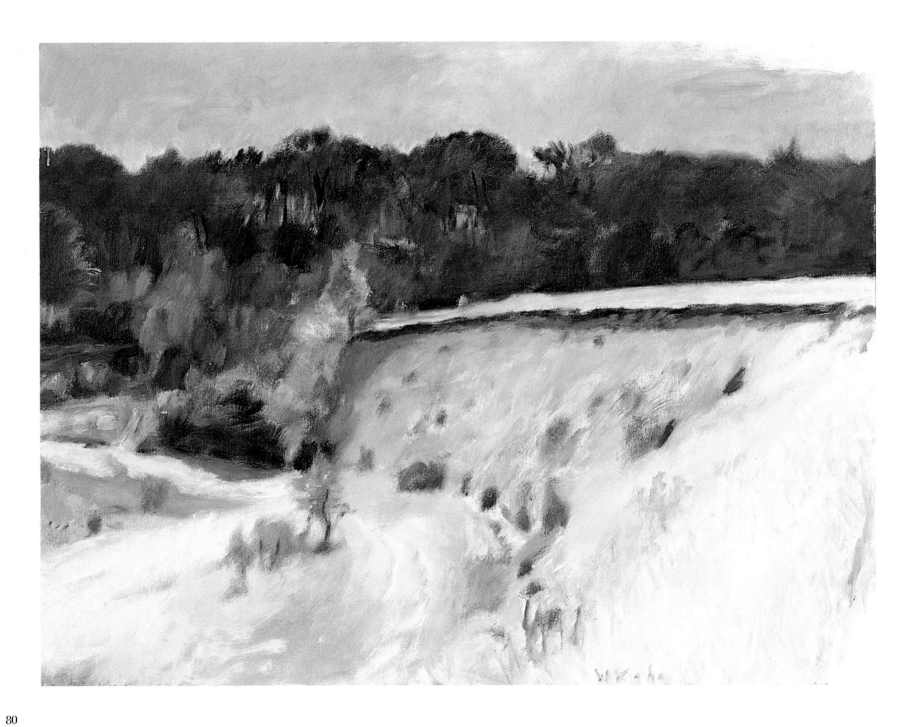

Upper Pasture V, *1979*
Oil on canvas
22 x 43"
Private collection, New York

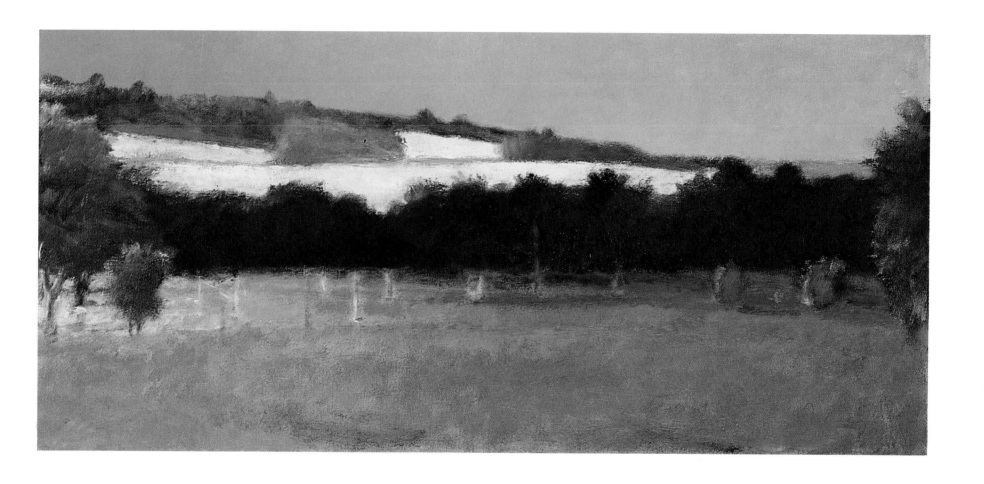

The End of the Plowed Road, *1980*
Oil on canvas
22 x 42"
Collection Grace Borgenicht Gallery N.Y.C.

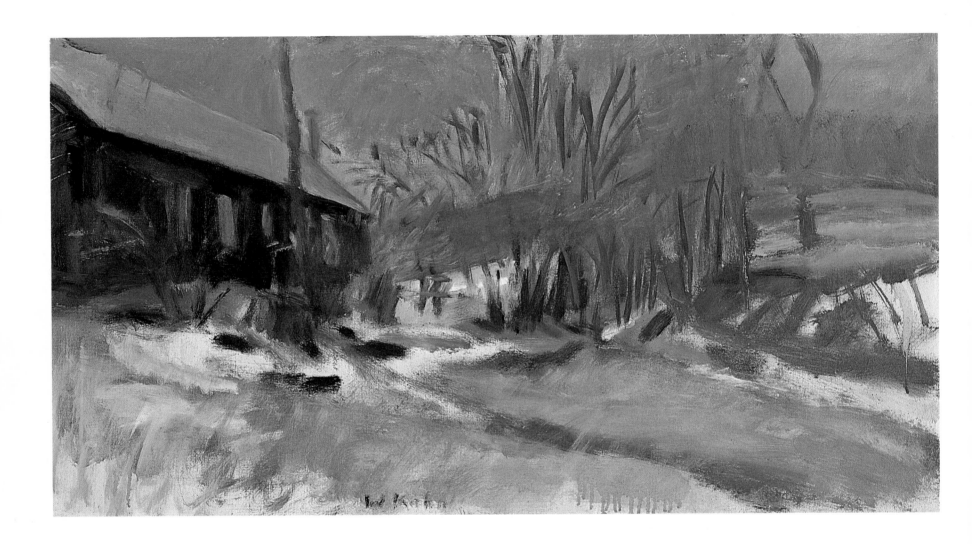

Homer Johnson's Studio, *1980*
Oil on canvas
22 x 38"
Collection S. Davis Mayfield, Houston

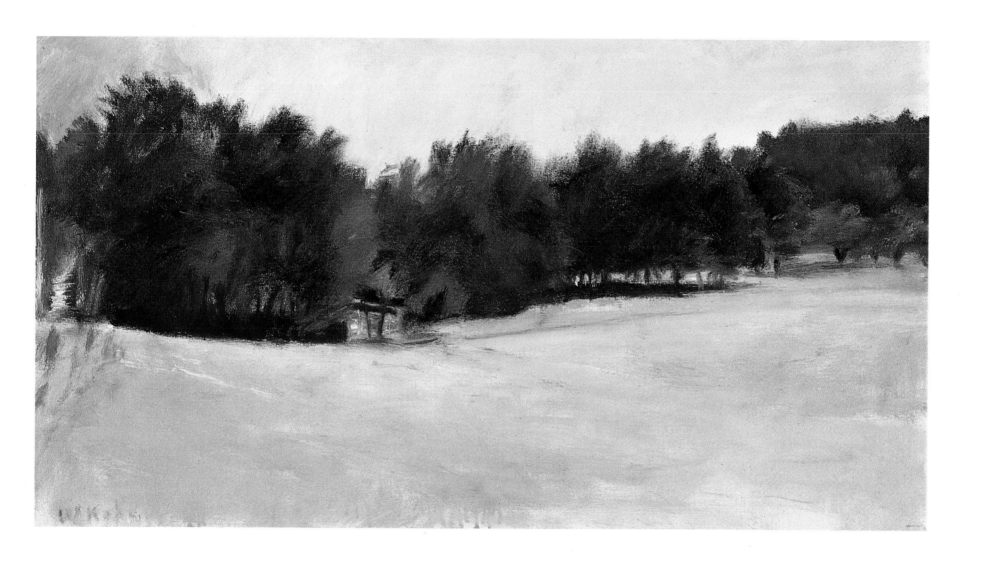

October Barn, *1979*
Oil on canvas
44 x 60"
Private collection, N.J.

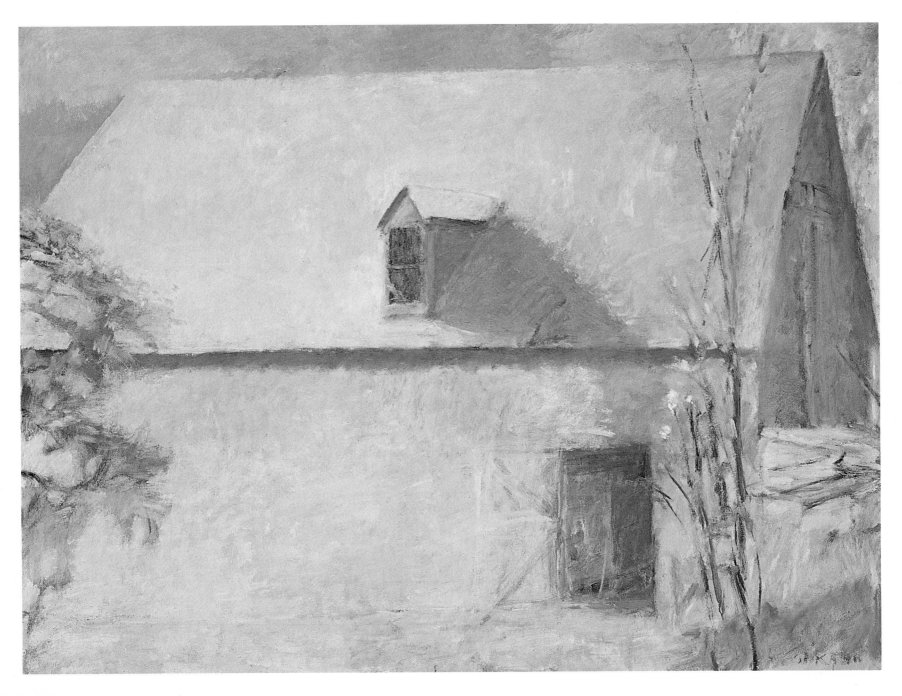

View Up the Mountain, *1976*
Oil on canvas
48 x 66"
Collection Mr. & Mrs. Lawrence Spivak, N.J.

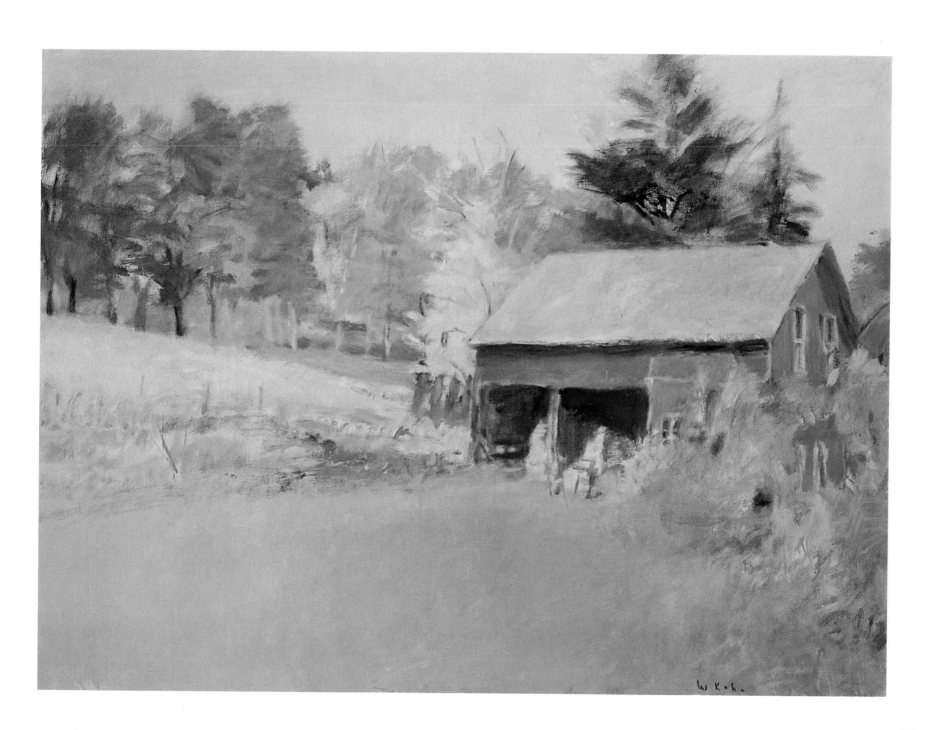

Barn and Blue Delphinium, *1979*
Oil on canvas
28 x 40"
Collection Cecily Kahn

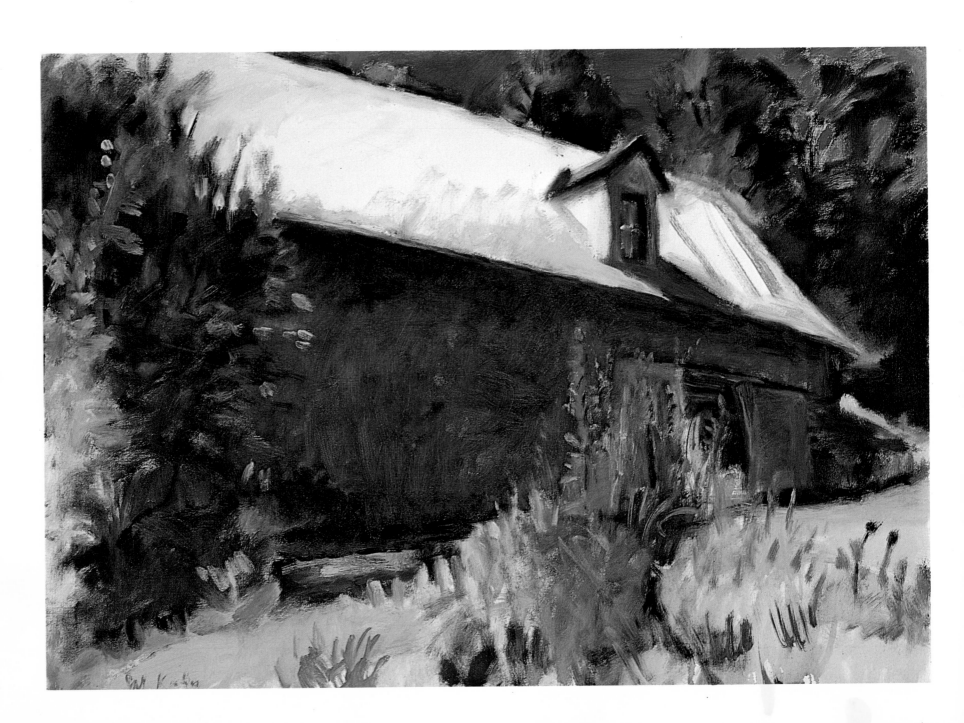

October Light, *1978–9*
Oil on canvas
30 x 41"
Collection C. Rohman, Lincoln, Nebraska

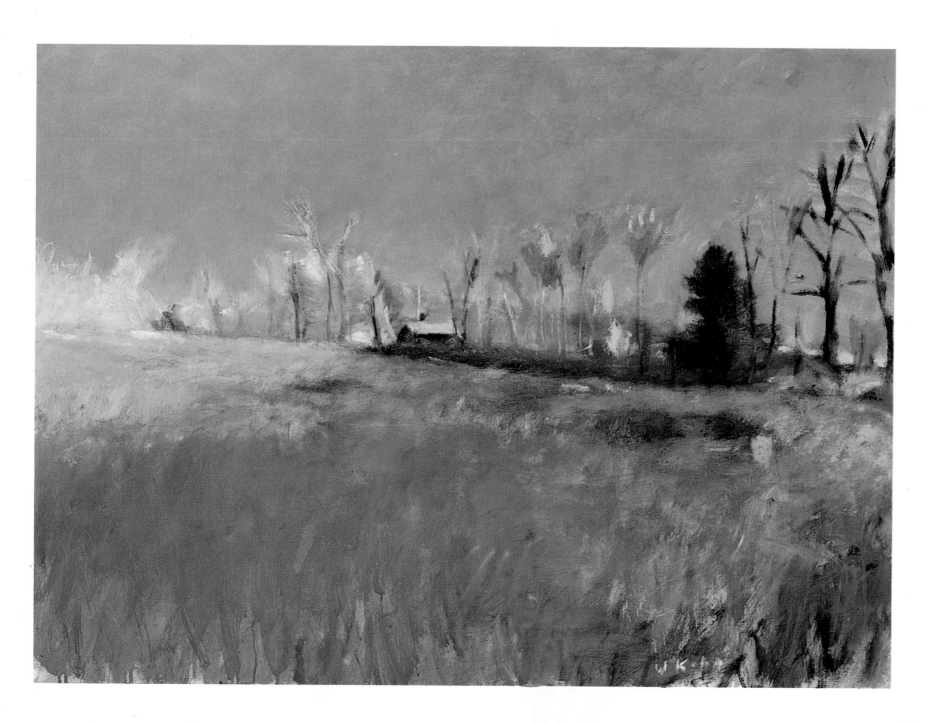

Brisk Weather, *1980*
Oil on canvas
28 x 44"
Collection of the artist

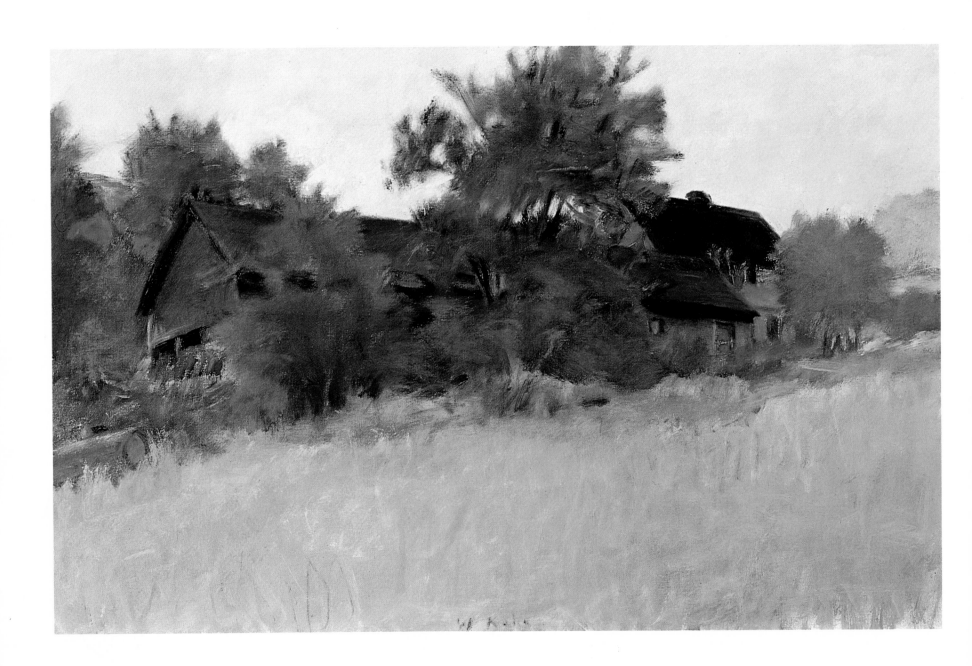

From Sword's "Stand of Elms," II, *1980*
Oil on canvas
40 x 52"
Collection Meredith and Cornelia Long, Houston

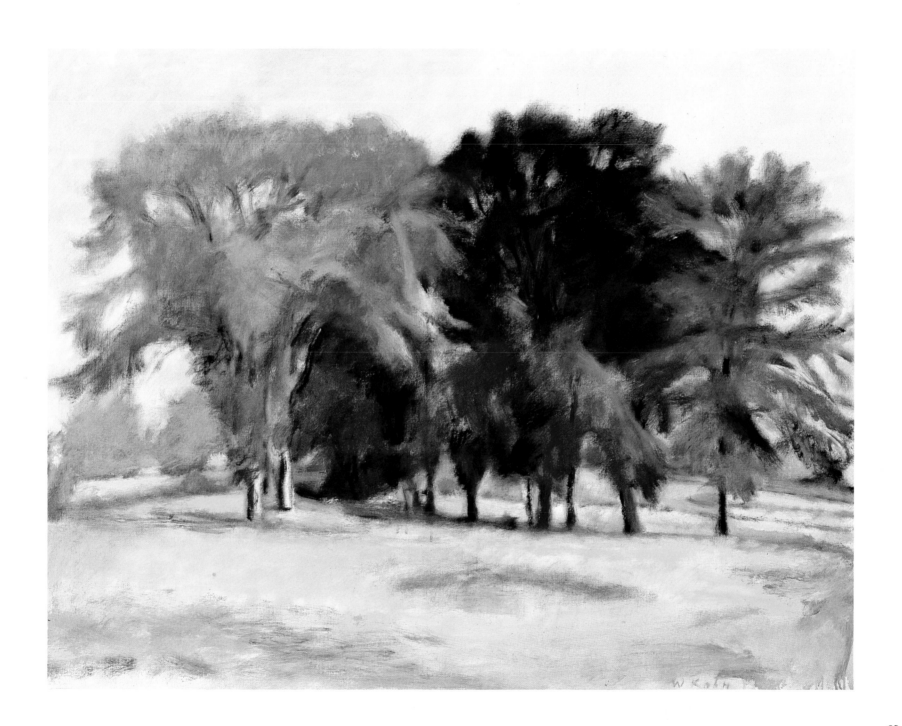

The Yellow Square, *1980*
Oil on canvas
44 x 78"
Collection Grace Borgenicht Gallery N.Y.C.

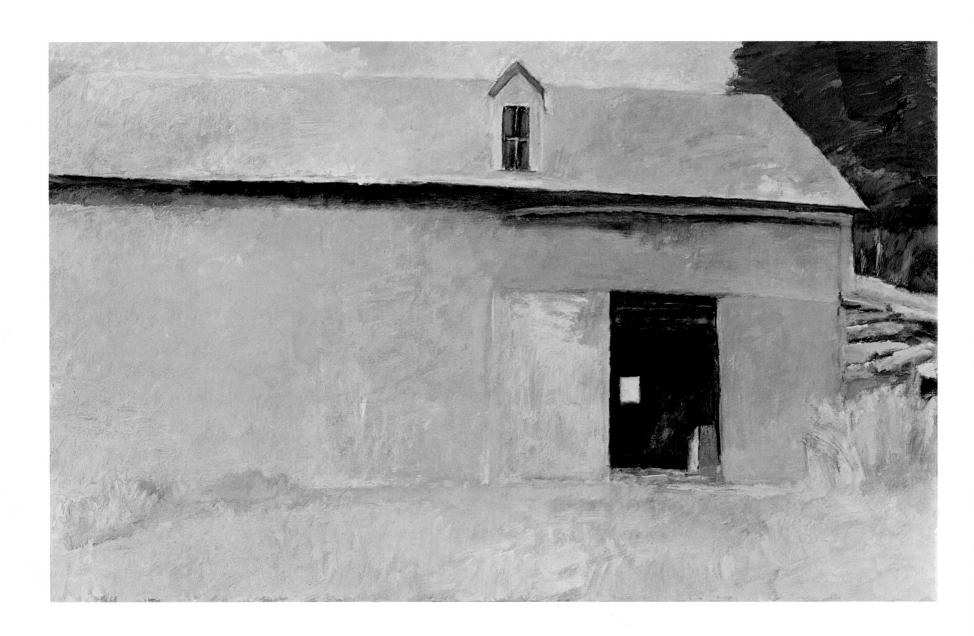

Pond in November, *1975–8*
Oil on canvas
29 x 36"
Collection National Academy of Design, N.Y.C.

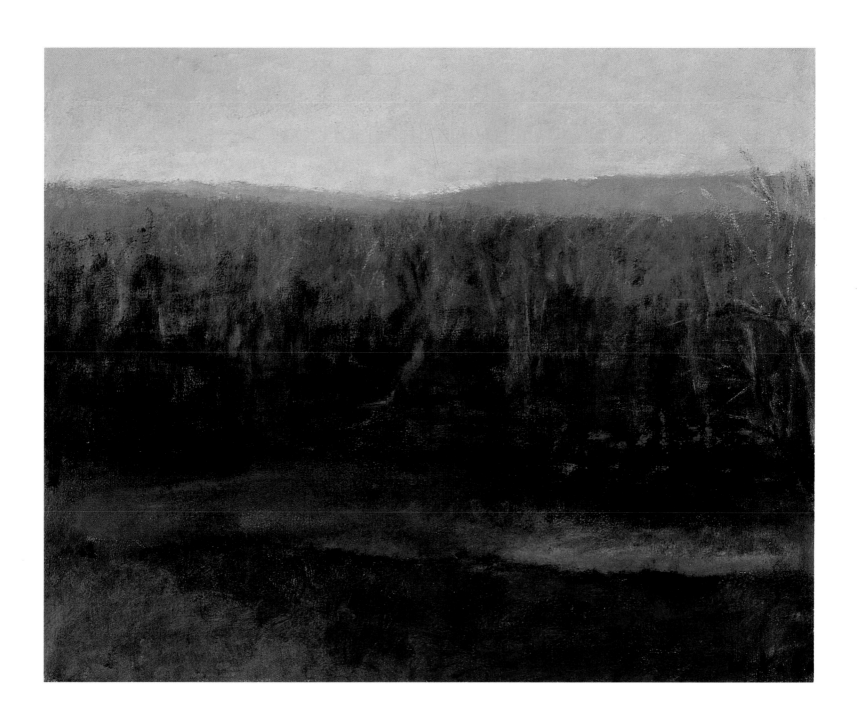

A Pink Day, *1980*
Oil on canvas
28 x 38"
Collection of the artist

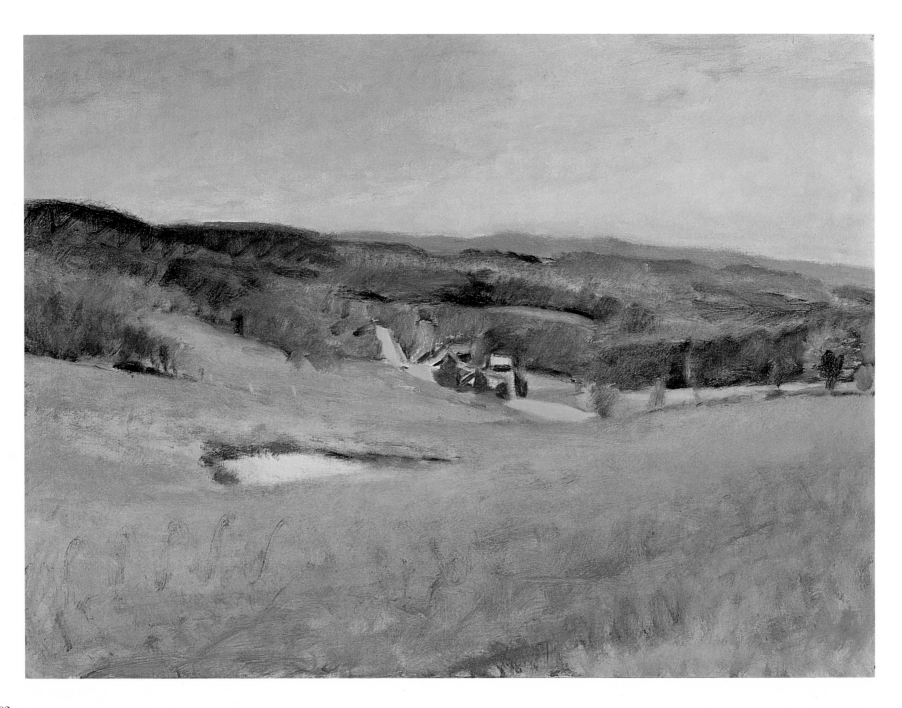

Chronology

1927
Born in Stuttgart, Germany, fourth child of Emil and Nellie Kahn.

1930
Moves to Frankfurt to live with his grandmother.

1937–1939
Attends Philantropin, "gymnasium" of the Frankfurt Jewish community. Private art lessons with Fraulein von Joeden.

1939
Sent to England in transport of refugee children two weeks before outbreak of World War II.

1940
Joins his father in U.S.

1943–1945
Moves to New York City and attends High School of Music and Art.

1945
Joins U.S. Navy, attends radio school, discharged 1946.

1946
Attends classes of Stuart Davis and Hans Jelinek at the New School for Social Research, N.Y.

1947–9
Joins Hans Hofmann's School of Fine Art, New York; also studied with Hofmann one summer in Provincetown. "New Provincetown '47" exhibition at Seligmann Gallery, New York

1950–51
B.A. University of Chicago.

1952
Takes loft at 813 Broadway. Organizes "813 Broadway" show. Founding member of cooperative Hansa Gallery.

1953
First one-man show, Hansa Gallery. Summer in Provincetown.

1954
Second one-man show, Hansa Gallery. Lives part of year in Louisiana. Shown in Stable Annual.

1955
Lives in Tepoztlan, Mexico.

1956
One-man show, Borgenicht gallery.

1957–8
Lives in Venice. Marries Emily Mason, March 2, 1957. Part of exhibition "New York School—The Second Generation" at The Jewish Museum N.Y.C.

1958
One-man show, Borgenicht Gallery.

1959
Birth of daughter, Cecily. Summer in Martha's Vineyard.

1960
Visiting professor at University of California, Berkeley. Included in Whitney Museum "Young America" exhibition. Summer in Martha's Vineyard.

1961
Joins faculty at Cooper Union. One-man show, Borgenicht Gallery. Summer in Stonington, Maine.

1962
One-man exhibitions at Borgenicht Gallery and Michigan State University. Teaches at Haystack School, summer in Deer Isle village, Maine. Awarded Fullbright for Italy.

1963
Lives in Milan, summer near Viterbo. One-man show, Kansas City Art Institute.

1964
Lives in Rome. Birth of daughter Melany.

1965
One-man show at Borgenicht Gallery. Summer in Martha's Vineyard.

1966
Awarded Guggenheim fellowship. One-man show, Sabersky Gallery, Los Angeles. Helped organize "Pastel Anthology" for Borgenicht Gallery.

1967
One-man show, Borgenicht Gallery. Summer in Deer Isle, Maine.

1968
Buys farm in West Brattleboro, Vermont where he spends subsequent summers.

1969
One-man show, Borgenicht Gallery.

1970
Commission to paint Litchfield Plantation, South Carolina.

1971
One-man exhibitions at Meredith Long Gallery, Houston and Borgenicht Gallery.

1972
One-man exhibitions at University of Nebraska, David Barnett Gallery, Milwaukee, Chrysler Museum, Norfolk, Va., and the Princeton Gallery of Fine Art.

1973
Travel in Kenya, part of summer in Italy. Exhibits at Meredith Long Gallery, Houston.

1974
One-man show, Borgenicht Gallery, Parker Street Gallery, Boston, Meredith Long Gallery, Houston. Spends part of summer in Corrèze, France.

1975
Exhibitions at David Barnett Gallery, Borgenicht Gallery and Princeton Gallery of Fine Art.

1976
Exhibitions at Meredith Long Gallery, Houston and Harkus-Krakow Gallery, Boston

1977
Chairman, College Art Association Committee for prize for distinguished teaching in art. One-man shows at Borgenicht Gallery, David Barnett Gallery, Meredith Long Gallery, Houston.

1978
One-man exhibitions at Fontana Gallery, Philadelphia. Meredith Long Gallery, Houston, Lillian Kornbluth Gallery. Fair Lawn, New Jersey.

1979
Art Award from American Academy of Arts and Letters. Made a member of the National Academy of Design. Exhibitions at Borgenicht Gallery, "Recent Acquisitions" Metropolitan Museum of Art N.Y.C.

1980
One-man exhibitions at Waddington Gallery, London and Meredith Long Gallery, Houston. Included in "Next to Nature" exhibition at National Academy of Design. Elected member of National Board of College Art Association.

Bibliography

By the artist

"Uses of Painting Today," *Daedalus*, winter, 1969, pp. 747–54.

"Painters reply," *Artforum*, vol. 14, Sept., 1975, pp. 27–28.

"Forum page: What is the proper training of the artist?" *American Artist*, vol. 40, March, 1976, p. 25.

"Subject Matter in the New Realism," *American Artist*, vol. 43, Nov., 1979, pp. 27–28.

Unpublished papers

"On going to art school," talk given at the New York Studio School, Dec. 14, 1973.

"On the Hofmann School," paper given at College Art Association, New York, January, 1973.

"Jan Muller," talk at the Educational Alliance, New York, April 5, 1975.

General books

Gussow, Alan, *A Sense of Place: the artist and the American land*, Saturday Review Press with Friends of the Earth, 1972.

Meyer, Susan, ed., *Twenty Landscape Painters and how they work*, Watson Guptill, New York, 1977.

Sandler, Irving, *The New York School*, Harper and Row, New York, 1978.

Young America, 1960, 30 American painters under 36, Whitney Museum, 1961.

Selected articles and reviews

Ashton, Dore, review of Hansa Gallery exhibition, *Arts Digest*, vol. 28, Nov. 1, 1953, p. 22.

_____, "Wolf Kahn," *Pen and Brush*, vol. III, No. 2. Feb., 1955, E. H. and A. C. Friederichs Co., New York.

Campbell, Lawrence, "In the mist of life, Wolf Kahn, passionate landscapist of hills and barns," *Art News*, vol. 67, Feb., 1969, pp. 42–43.

_____, review of Borgenicht Gallery exhibition, *Arts*, vol. 48, March, 1974, p. 71.

Cochrane, D., "Wolf Kahn: updating landscape painting," *American Artist*, vol. 38, Nov. 1974, pp. 58–63.

De Kooning, Elaine, "Subject: what, how, or who?" *Art News*, April, 1955, pp. 60–64.

Greenberg, Clement, "Art," *The Nation*, vol. 165, No. 15, October 11, 1947, p. 389–90.

Hess, Thomas B., "U.S. Painting: Some Recent Directions," *Art News Annual*, 1956, pp. 80–89.

Judd, Don, "813 at Zabriskie." *Arts*, vol. 36, Feb., 1962, p. 45.

Kramer, Hilton, review of exhibition at Hansa Gallery, *Arts Digest*, Feb., 1955.

Mellow, James R., review of exhibition at Borgenicht Gallery, *Art International*, vol. 13, April, 1969, p. 37.

Museum of Modern Art Bulletin, vol. 24, no. 4, summer, 1957, "New Acquisitions," p. 33.

O'Hara, Frank, "Nature and the New Painting," *Folder*, No. 3, Tiber Press, New York, 1955.

Petersen, V., "Young Americans, seen and heard at the Whitney Museum," *Art News*, vol. 59, Nov., 1960, p. 58.

Porter, Fairfield, review of Hansa Gallery exhibition, *Art News*, vol. 52, Nov., 1953, p. 11.

_____, review of Hansa Gallery exhibition, *Art News*, vol. 53, Feb., 1955, p. 56.

Preston, Stuart, review of Hansa Gallery exhibition, *New York Times*, Nov. 3, 1953.

Rosand, David, "A response to Wolf Kahn, Borgenicht Gallery, New York, 1979.

Sawin, Martica, "The landscape Paintings of Wolf Kahn," *Arts*, vol. 51, April, 1977, pp. 132–135.

_____, "Wolf Kahn," Arts Review, London, 29 August, 1980, vol. XXXII, No. 17, p. 370–71.

Schapiro, Meyer, "The Younger American Painters of Today," *The Listener*, Jan. 26, 1956, pp. 146–47.

Schjeldahl, Peter, "Wolf Kahn," *New York Times*, Sunday, Nov. 19, 1972.

Tillim, Sidney, review of Borgenicht Gallery exhibition, *Arts*, vol. 36, May, 1962, p. 101.

Viereck, Peter, "Some refrains at the Charles River," accompanying illustration by Wolf Kahn. *Art News Annual*, 1955, pp. 84–85.

Exhibition reviews
(in order of occurrence)

Arts and Architecture, vol. 72, March, 1955, p. 82. Hansa Gallery exhibition.

Art News, vol. 55, December, 1956, p. 10. Borgenicht Gallery exhibition.

Arts, vol. 31, December, 1956, p. 52. Borgenicht Gallery exhibition.

Art News, vol. 57, January, 1959, p. 12. Borgenicht Gallery exhibition.

Arts, vol. 33, January, 1959, p. 56, Borgenicht Gallery exhibition.

Art News, vol. 59, February, 1961, p. 12. Borgenicht Gallery exhibition.

Arts, vol. 35, February, 1961, p. 54. Borgenicht Gallery exhibition.

Art News, vol. 64, April, 1965, p. 12. Borgenicht Gallery exhibition.

Arts, vol. 39, May, 1965, p. 68, H. Bronstein, review of Borgenicht Gallery exhibition.

Arts, vol. 41, February, 1967, p. 59, Borgenicht Gallery exhibition.

Art News, vol. 65, February, 1967, p. 15. Borgenicht Gallery exhibition.

Arts, vol. 43, March, 1969, p. 58. Borgenicht Gallery exhibition.

Art in America, vol. 58, May, 1970, p. 101; "Barn after Rain" reproduced.

Arts, vol. 45, February, 1971, p. 54. Borgenicht Gallery exhibition.

Art News, vol. 69, February, 1971, p. 21. Borgenicht Gallery exhibition.

Art News, vol. 71, December, 1972, p. 46. Borgenicht Gallery exhibition.

Arts, vol. 47, December, 1972, p. 96. Borgenicht Gallery exhibition.

Artforum, vol. 14, February, 1973, p. 87. Borgenicht Gallery exhibition.

Art in America, vol. 61, May, 1973, pp. 56–57. Borgenicht Gallery exhibition.

Art International, vol. 17, January, 1973, p. 75. Borgenicht Gallery exhibition.

Art News, vol. 73, May, 1974, p. 100. Borgenicht Gallery exhibition.

Artforum, vol. 12, June, 1974, p. 66. Borgenicht Gallery exhibition.

Arts, vol. 49, June, 1975, p. 15. Borgenicht Gallery exhibition.

Art News, vol. 74, summer, 1975, p. 146. Borgenicht Gallery exhibition.

Art News, vol. 75, November, 1976, p. 114. Harcus Krakow Gallery exhibition, Boston.

Art News, vol. 76, summer, 1977, p. 189. Borgenicht Gallery exhibition.

Art News, vol. 77, December, 1978, p. 125. Fontana Gallery exhibition, Philadelphia.

Arts, vol. 53, April, 1979, p. 125. Borgenicht Gallery exhibition.

Design
Page, Arbitrio & Resen

Typography
Dumar Typesetting, Inc.

Printing
Eastern Press, Inc.

Photography
Daniel Brinzac: pp. 6, 9, 34, 36, 40-42, 44, 45,
47-51, 53-55, 57, 63-69, 73-77, 79-92
Rudolph Burckhardt: pp. 8, 10-14, 16, 17
John Schiff: pp. 20-22, 24-28, 31, 37, 39
Malcolm Varon: pp. 56, 58-62, 70-72, 78